IMAGES
of America
ST. PETERSBURG'S
PIERS

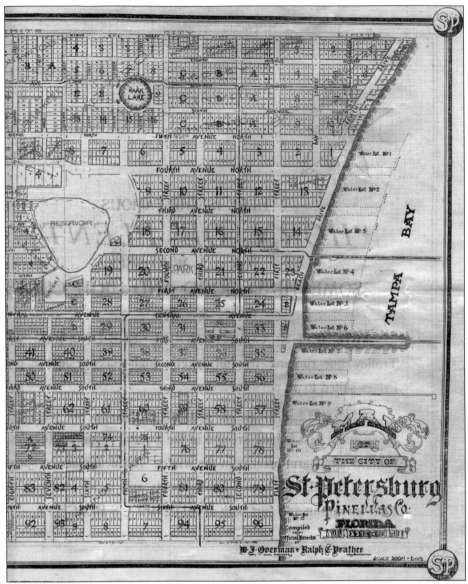

This 1908 map is a good reference guide for the location of major city attractions, not the least of which was the municipal pier, at the eastern end of Second Avenue North. Note that the current Mirror Lake is designated only as "Reservoir." It was indeed the new town's sole source of freshwater for a few years, until wells could be drilled. (Courtesy of the St. Petersburg Museum of History.)

ON THE COVER: The Mediterranean-style casino at the head of the Million Dollar Pier is packed with cars and people in its heyday as the central gathering point in the growing tourist village of St. Petersburg. The enduring structure is probably the most fondly remembered pier of those that have graced the St. Petersburg waterfront. Despite the impressive name, the attraction actually came in slightly under the then-extravagant construction budget of $1 million. During the boom years, the Million Dollar was the place to see and be seen in the Sunshine City. (Courtesy of the St. Petersburg Museum of History.)

IMAGES
of America

ST. PETERSBURG'S PIERS

Nevin D. Sitler

ARCADIA
PUBLISHING

Published by Arcadia Publishing
Charleston, South Carolina

Printed in the United States of America

Library of Congress Control Number: 2014952689

For all general information, please contact Arcadia Publishing:
Telephone 843-853-2070
Fax 843-853-0044
E-mail sales@arcadiapublishing.com
For customer service and orders:
Toll-Free 1-888-313-2665

Visit us on the Internet at www.arcadiapublishing.com

*To the St. Petersburg Museum of History trustees,
staff, and volunteers; thank you for your dedication to
preserving the rich history of the Sunshine City*

CONTENTS

ACKNOWLEDGMENTS

Numerous individuals and organizations contributed to the completion of *St. Petersburg's Piers*. First and foremost, I must thank my father, Richard Nevin Sitler. Not only did he bestow a great name upon me, but he instilled his love and passion of communicating and sharing a good story to me very early in my life. He has acted as editor, mentor, and soundboard for nearly every professional project that I have been blessed, or crazy enough, to take on. Thanks, Pops.

While attending the University of South Florida's Florida Studies Graduate Program, I was lucky enough to have been groomed and encouraged by a rare and very talented advisor and instructor; many thanks to you, Dr. Gary Mormino. After 10 years, he still provides me with monthly microfiche printouts and a dip into what "Mr. Florida" is writing about and researching these days. I recall his first assignment for me as his graduate assistant: "Find me how many head of cattle were in Polk County in 1950." What? Really? That is how I can best serve you?, I thought. It took me a few years to realize that he was encouraging me to be a dogged researcher, to look into the odd question, the oft-repeated tale, and to tell my story my way. Like Mr. Miyagi from *The Karate Kid*, he snuck in the knowledge, and I will always appreciate him.

Without the assistance and support of the Hough Family Foundation, I would not be where I am today, nor perhaps would the St. Petersburg Museum of History. Thank you, Bill, Hazel, and especially, your amazing daughter Dr. Susan Hough Henry.

And speaking of the St. Petersburg Museum of History, those who know me and my work here at the city's oldest museum know of my passion and appreciation for the Sunshine City. It is a great honor to share our city's rich and vibrant history, and it is my pleasure to donate all author royalties of this book to the St. Petersburg Museum of History's Archives Department. It is my hope that our collections will continue to inform and educate our citizens for another 94 years.

All images in this volume appear courtesy of the St. Petersburg Museum of History.

INTRODUCTION

Since 1854, several piers of some fashion have stretched into Tampa Bay from St. Petersburg's shores. Early piers in the fledgling community were designed with trade and commerce in mind, while 20th-century piers centered on tourism and pleasure-seekers.

Following passage of the 1850 Florida Swamp Land Act, which freed up nearly 15 million acres of land for railroads and settlers, Lt. C.H Berryman, a US Navy surveyor, constructed a small settlement and short pier near present-day Fifth Avenue North. Responding to Sen. David Yulee's plans to extend a railroad line from Fernandina to Tampa Bay, Berryman recorded over 30,000 soundings of the waters and cited downtown St. Petersburg as an optimal site for a deepwater seaside railroad depot. When plans changed and the rail line extended only to Cedar Key, Berryman's hamlet concept was soon abandoned. However, his 1855 report on his findings fueled railroad mogul Peter Demens's desire to extend his line into the Tampa Bay area.

Although abandoned by the Navy, Berryman's carpenter, William Paul, returned to take possession of the small hamlet he helped to build. It was later known as Paul's Landing. William Paul planted the first orange grove on the peninsula. By 1859, he left to take care of his ill wife.

With the outbreak of the Civil War, the quest for a deepwater port in St. Petersburg was put on hold. But it was not forgotten. By 1889, Peter Demens had completed his Orange Belt Railroad extension into the heart of St. Petersburg, terminating the line 2,000 feet into the bay as a shipping port. The Railroad Pier also offered unlimited opportunities for anglers, sunbathers, and the carefree who dared the pier's toboggan slide. A few years later, in 1896, D.F.S. Brantley's pier delighted visitors with a horse-drawn flatcar used to shuttle goods and passengers from water's edge to and from moored ships.

In 1901, Edwin Tomlinson's Fountain of Youth attraction on his pier promised to rejuvenate the body and soul with his curative well water. By 1906, Frank Davis had trolley lines, and hundreds of lightbulbs extended over his "Electric Pier." Next, in 1913, came the Municipal Recreation Pier at the foot of Second Avenue North. To the consternation of many business-minded folks attempting to cash in on docking and pier usage fees, it seemed as if the city had more piers than pelicans.

Following years of "pier wars," waterfront improvement initiatives, and the devastating 1921 hurricane, which destroyed all of the waterfront piers, boosters and civic leaders pushed for a grander replacement to the beloved attractions. With a name to match the construction costs, the Million Dollar Pier opened in 1926 to immediate fanfare. The Mediterranean-themed pier was the brainchild of *Evening Independent* publisher Lew Brown. It offered dancing, shopping, and recreation. Ever since the city's birth, piers had proved popular, but the 1926 incarnation had something more; it became an instant destination for money-spending tourists.

During these heady years, city boundaries expanded. Scores of impressive boom-time hotels rose skyward, as did land prices and census figures. St. Petersburg's population, which topped 14,000 by 1920, had nearly doubled as the boom was in full swing four years later. By the 1960s, nearly 182,000 folks called St. Pete home.

The year 1967 was a tumultuous one, as Martin Luther King Jr. prepared to protest the war in Vietnam, and unprecedented and deadly race riots continued across the nation. And the city of St. Petersburg was in the midst of its own contention. The city's landmark, the Million Dollar Pier and Casino, had just landed on the butcher's block. The pier and casino were being replaced. After 41 years of operation and subsequent disrepair, time and decay demanded replacement. For four decades, this monument to excess and indulgence hosted ballroom dances, choir sing-alongs, card parties, and nearly any other event a leisured population demanded.

As journalist Paul Schnitt reported, "The 'Million Dollar Pier' was the pride of Florida's West Coast . . . it was a shimmering spear in Tampa Bay, and the pride of St. Petersburg . . . and was the center to the city's appeal to tourists." The dissent regarding the structure's August 1967 destruction was less than astonishing. Editorials published by the *Independent* and the *Times*, proclaimed sentimental shock. Just how loud or lazy the "Save our Pier" program was can be summarized by the minuscule 600 signatures presented to the city council in protest to the demolition. And no one was prepared to take City Councilman William Allison up on his willingness to reconsider securing a $50,000 lease on the property.

Within a few weeks, demolition bids were announced, and the pier met its demise. The pier head would be nothing more than a paved park for the next five years. Interestingly, the looming and essentially undisclosed piece of the puzzle came down to questions of why. Why destroy the pier's recreational structures during the summer vacation months, when dancing and fishing could be at full swing? And many wanted to know why there were no plans already in place for the next phase of St. Petersburg's landmark.

As the century closed with moonwalks and Woodstock, St. Petersburg searched for its next pier, its next image. The rather hurried demolition of St. Petersburg's Million Dollar Pier recreation pavilion spoke loudly of the city's intent for change. It also spoke of the silent insecurity of an aged identity.

The eventual construction of a modern, inverted pyramid was a blatant attempt to shed the old and prove the city's commitment to a new, younger identity. In hindsight, there are questions as to whether it was a needed catalyst for change. Perhaps it was, but probably not. The same subtropical climate and exotic terrain that lured investors and dreamers to 19th-century Florida continue to shape the Sunshine City in the 21st century. The future of St. Petersburg shows little indication of providing anything short of astonishing growth and economic possibilities.

To the excitement of some and the disappointment of others, the Inverted Pyramid, like the Million Dollar Pier, faces the wrecking ball after standing as a proud city landmark for over four decades. And we ponder the future.

One

EARLY ST. PETERSBURG
1854–1913

The first pier on record was the result of a US Navy surveyor's search for a suitable site for a railroad depot and a deepwater port for cargo ships in 1854. Although it was quickly abandoned by the Navy, the quest for suitable dockage was under way.

From the small pier and wharf constructed by the area's first permanent settler, John Bethell in 1868, to railroad magnate Peter Demens's 2,000-foot pier completed in 1889, the city was destined to make use of its waterfront. The Bethell family's short pier extended over waters just five feet deep, but that was enough to attract Cuban and Key West traders. Fresh fruits, vegetables, and pickled mullet were bartered for other necessities unavailable on the remote peninsula.

Demens's pier extended nearly half a mile into the bay, reached depths of 12 feet, and allowed for passenger travel via steamboats. It provided the tourist trade with a major boost. One of Florida's most important industries, the shipping of fresh fish, started that same year, when Henry Hibbs leased a shed from the Atlantic Coast Line pier and began his commercial fishing business.

The Railroad Pier offered opportunities for anglers, sunbathers, and the carefree who dared the pier's toboggan slide. In 1896, D.F.S. Brantley's pier delighted visitors with his horse-drawn flatcar used to shuttle goods and passengers from water's edge to the shore.

St. Petersburg's reputation as a healthful place to live, and the concept of piers used exclusively for recreation, grew rapidly. In 1901, the Tomlinson's Fountain of Youth attraction on his pier promised to rejuvenate the body and soul. By 1906, Frank Davis had trolley lines and installed hundreds of lightbulbs over his "Electric Pier." The Municipal Recreation Pier at the foot of Second Avenue North was constructed in 1913, just 10 feet to the north of the Electric Pier.

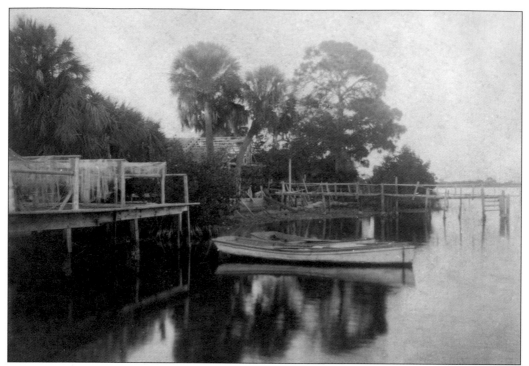

Big Bayou pioneer John Bethell and his three sons used rustic poles and roughhewn planks to build and operate the late 1800s dock seen above. Though small and crude, some historians consider it to be one of the earliest "piers" on the Pinellas Peninsula, mooring boats that sailed to and from Key West and Cuba. Below, Bethell (third from left) poses with his sons at their Big Bayou boatyard. Fishermen, traders, and small passenger craft were able to take on supplies or have their vessels patched and repaired.

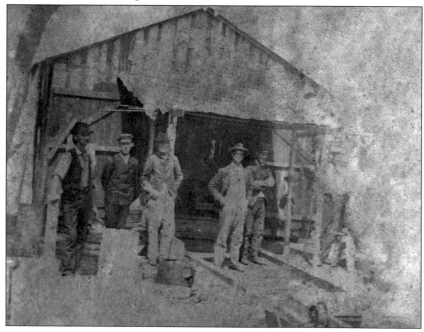

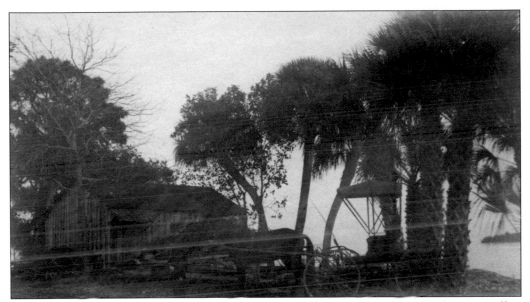

The Bethell family boatyard operation near Big Bayou also served as the area's first post office in the southern end of the county. From 1876 to about 1885, John and Sarah Bethell's cabin was known as the Pinellas Village Post Office. Sarah and her daughter both served as postmistresses until it closed in 1907. A desk they used for incoming and outgoing mail is on permanent display at the St. Petersburg Museum of History.

The first pier on record was the result of a US Navy surveyor's 1854 search to locate a site for a railroad depot and a deepwater port for cargo ships. Although the pier was soon abandoned, the quest for suitable dockage was under way. This 1892 photograph of local fishermen shows how quickly commerce gave way to recreational use. Early piers in the fledgling community were designed with trade and commerce in mind, while 20th-century piers centered on tourism and recreation.

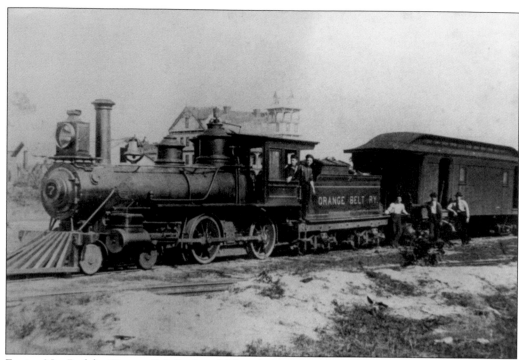

Engine No. 7 of the Orange Belt Railroad (above) chugged into St. Petersburg as early as 1890 with passengers registered as guests of the Detroit Hotel (below). The rail line and hotel comprised two-thirds of the formula devised by developer Peter Demens. The third part, of course, was a functional railroad pier extending into the bay, connecting people and goods to ship-bound destinations.

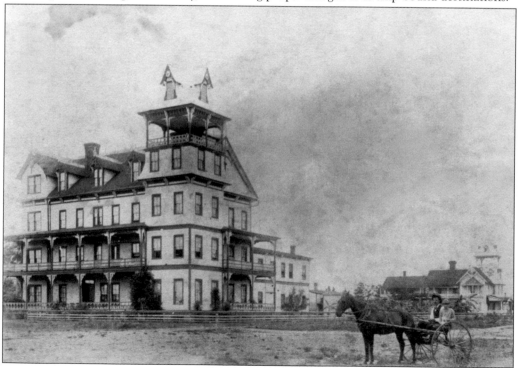

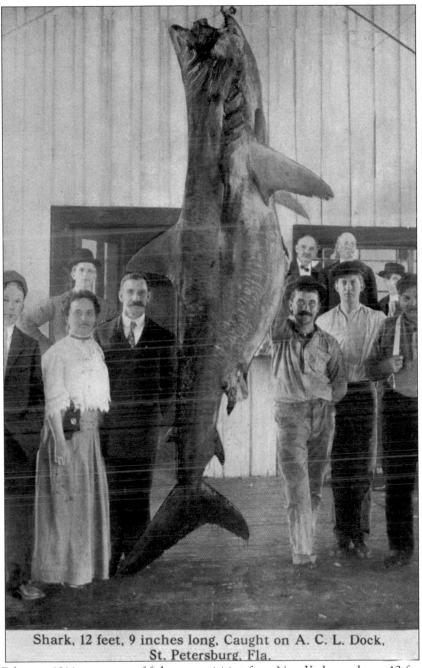

Shark, 12 feet, 9 inches long, Caught on A. C. L. Dock, St. Petersburg, Fla.

In early February 1914, a quartet of fishermen visiting from New York caught an 12-foot, 9-inch shark from the Atlantic Coast Line (ACL) pier, causing quite a stir among fellow anglers and visitors. The catch was believed to be one of the biggest sharks ever landed at the pier. A photograph of their catch was quickly turned into a postcard by C.C. Allen, "the Postcard Man," making it possible for the fishermen to mail off a "bragging rights" souvenir to friends back home. Allen's "the big fish" postcards were favorite souvenirs, sent to every state in the country during periods of aggressive tourist promotion. From his Central Avenue studio, Allen sold a selection of souvenirs, from shells and coconuts to palmetto hats handmade by Lucy Eady.

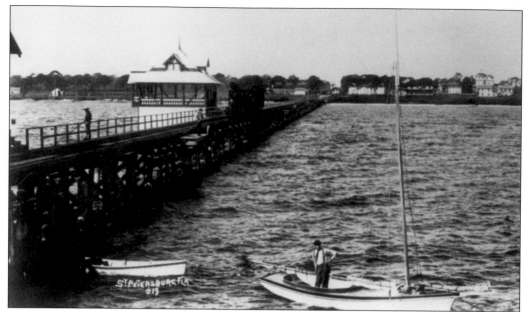

The bathhouse located on the ACL pier boasted in 1894 that it was the only place in town where guests could obtain a soothing saltwater bath with freshwater rinse. Proprietor J.D. Fletcher, said to be an excellent businessman and outgoing entrepreneur, offered northern guests one bath for 25¢ or a special of five baths for $1. Customers came to the bathhouse by sailboat, on foot, and by mule-drawn railcar.

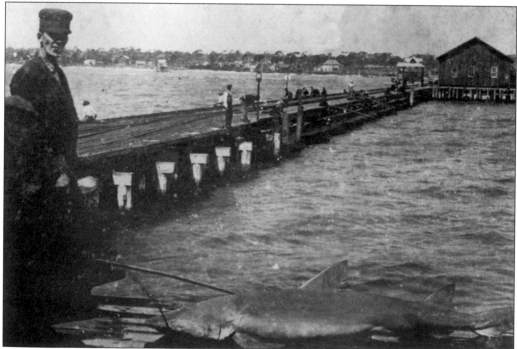

The ACL Railroad Pier, seen here from the east, tried to enforce a "no fishing" policy for safety reasons. But that 1900 effort was mostly for show and was ignored by locals, who caught "the big ones," as displayed here by a stern-looking angler.

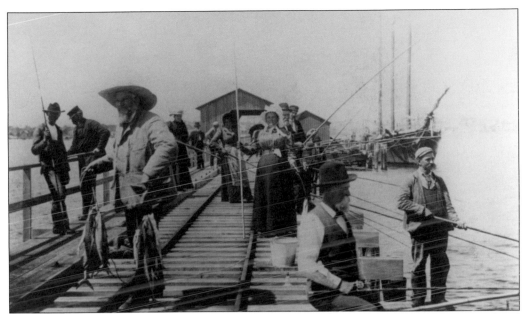

A local fisherman identified as George Meirs (right) appears to be content to remain seated and wait for another bite in this 1897 scene on the Railroad Pier. A fellow angler (left) makes his way back to the shoreline with his catch for the day.

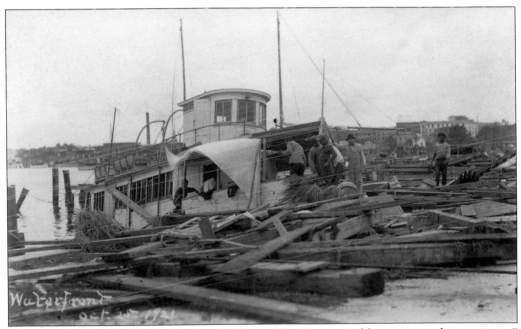

Homesteader Charles Braaf, who described himself as "a practical boat man and an engineer," received War Department permission in 1906 to build a private pier at the foot of Fifth Avenue North. Located in what is now the Vinoy Basin, it was remembered as "the most pleasant of walks in the city." When the 1921 hurricane hit, Braaf Pier, valued at $10,000, vanished, along with remnants of Paul's Landing and several other small docks built in the same vicinity.

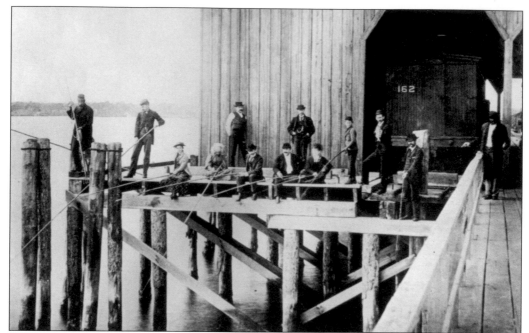

The Railroad Pier offered unlimited opportunities for anglers, sunbathers, and the carefree who dared the pier's toboggan slide. A few years later, in 1896, D.F.S. Brantley's pier delighted visitors with his horse-drawn flatcar used to shuttle goods and passengers from water's edge to shore.

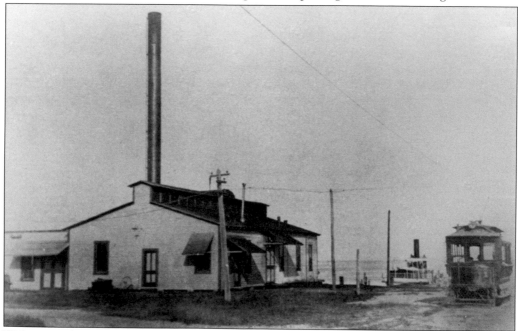

Welton's Dock was built about 1900 by Albert (or Alfred) Welton, an agent for a Tampa construction-materials company. Extending 50 feet into the water, it could be used only by shallow-draft boats. In 1902, while repairing a boat at his dock, Welton broke a leg. His son ran the business for another year, until the decaying dock was torn down. A small portion of the dock is visible here between the trolley and power plant, which would later become the St. Petersburg Yacht Club.

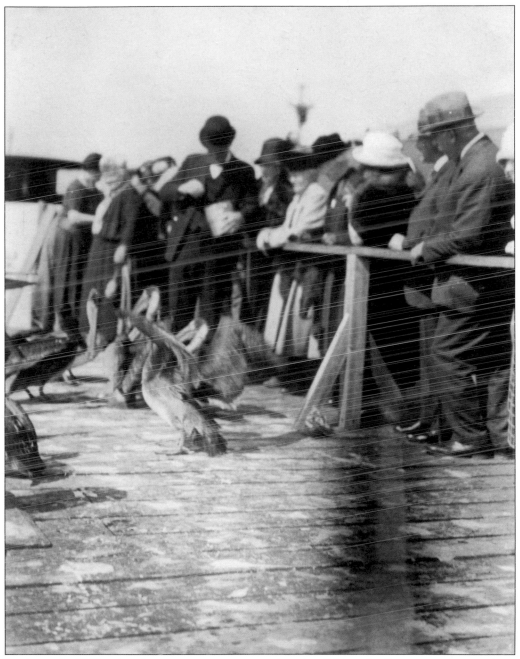

In the early 1900s, the place to congregate was the pier. Pelican feeding, a popular pastime, was often the subject of postcards sent back to northern friends. One such card included the note, "You would not believe how much food these awkward brown beggars can stuff into their enormous beaks."

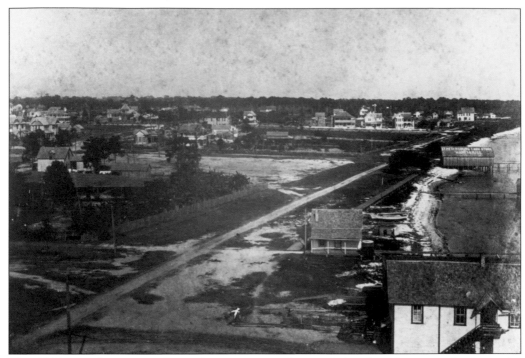

This 1904 waterfront scene shows the uninterrupted natural shoreline that existed prior to the development of piers and marinas. Welton's Dock (upper right), the Cash Store warehouse (center), and Brantley's home (bottom right) are seen here.

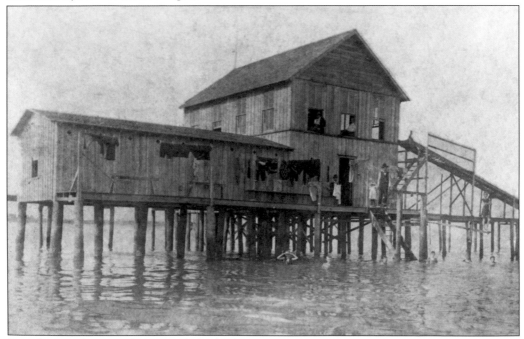

Brantley's Bathing Pavilion provided a shady retreat from the Florida sun in the scorching summer months. Usually, a light breeze kept the humid air circulating through the swimming attraction, making it a favored place for younger folks to gather.

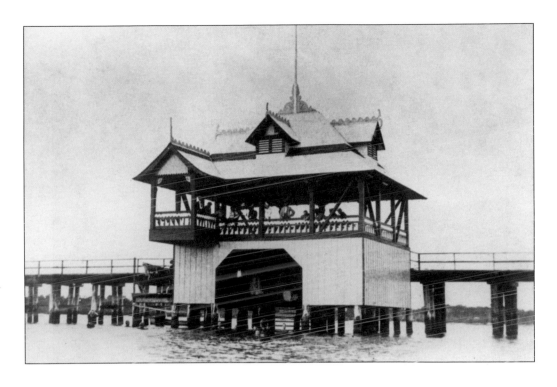

From John Bethell's small wharf to railroad magnate Peter Demens's 2,000-foot pier completed in 1889, the city was destined to make use of its waterfront. In 1891, this stylish pier bathhouse was added to the Railroad Pier, attracting swimmers away from Brantley's competition. The architectural style of the bathhouse is similar to that of the Detroit Hotel, also built by the railroad.

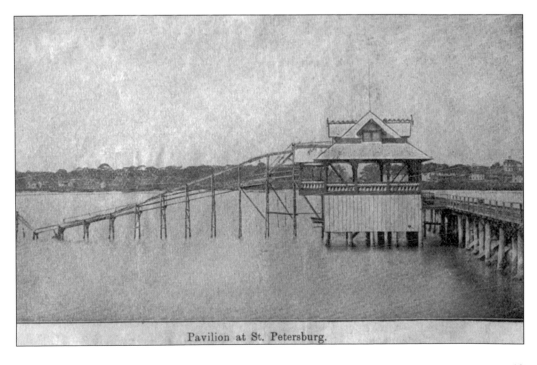

Pavilion at St. Petersburg.

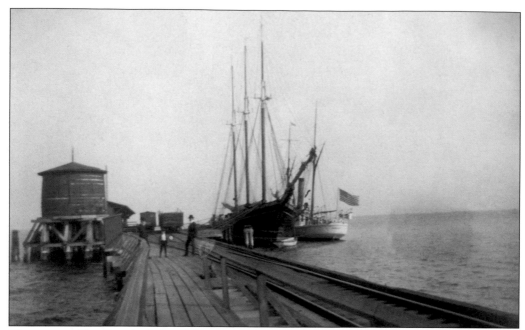

The steamer *Hamilton* (right) and the schooner *Pendleton Satisfaction* are moored alongside each other at the Railroad Pier. *Hamilton* made frequent daily trips in the early 1900s across the bay to Tampa, shuttling both passengers and small-freight consignments. The three-mast schooner typically sailed pleasure cruises around the southern tip of the Pinellas Peninsula to various Gulf of Mexico ports of call.

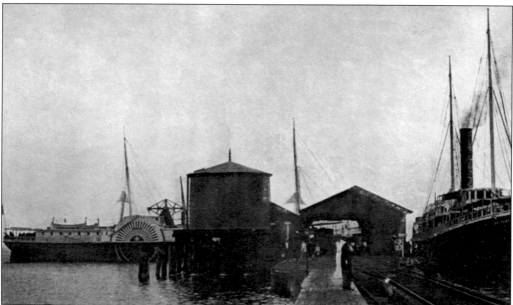

In 1898, Port Tampa was clogged with ships, railroad cars, and hundreds of soldiers, including Teddy Roosevelt and his Rough Riders, eager to get into the Spanish-American War. As the Tampa staging area quickly became overrun and dried up, troop ships sailed across the bay to the ACL railroad pier to take on freshwater, fed through a temporary pipeline from Reservoir Lake, now known as Mirror Lake.

From kids with cane poles to the fashionable elite, the St. Petersburg waterfront, particularly its piers, were the place to see others and to be seen. The Railroad Pier provides a background for the fashionable lady shown right to pose with her rather large hat, while the young angler below poses for the camera before catching "the big one."

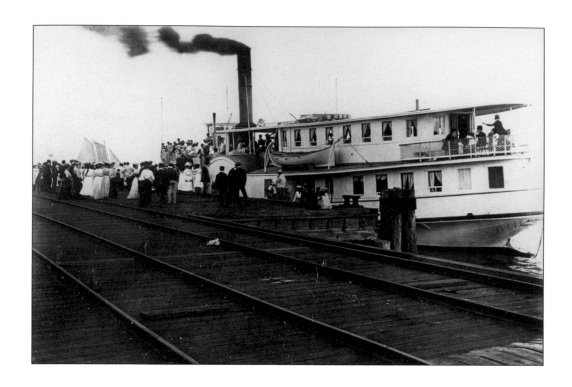

Black smoke belches from the stack of the steamer *Manatee* as she approaches the Railroad Pier (above). Fishing convenience at its best included easy access to the water and covered shade areas, despite signs clearly prohibiting fishing along the railway. An ACL boxcar can be seen in the background of the 1905 photograph below.

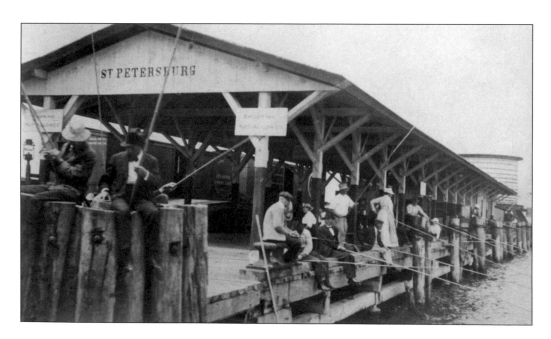

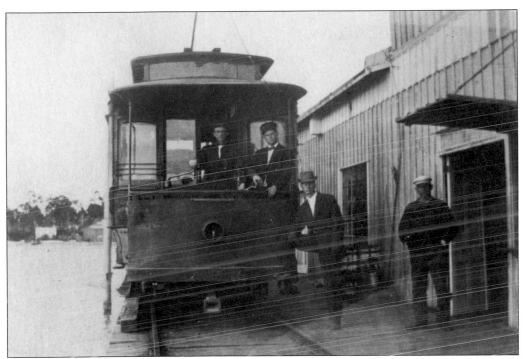

By 1906, Frank Davis had completed installation of electric lights and trolley rails on his Electric Pier. The city could boast more than eight miles of trolley track. Ken Johnson, shown above standing beside his car on the Gulfport pier, operated the intercity trolley for more than 30 years. When he once threatened to quit, Davis enticed him into staying on the job with a raise in pay and installation of a larger, more comfortable operator's seat.

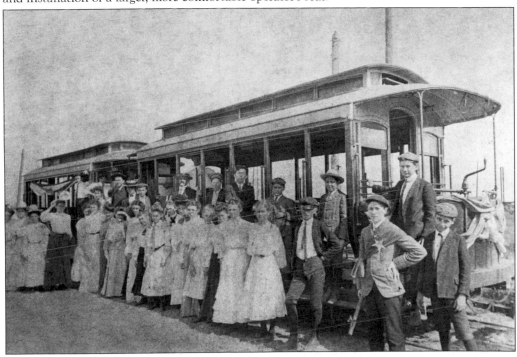

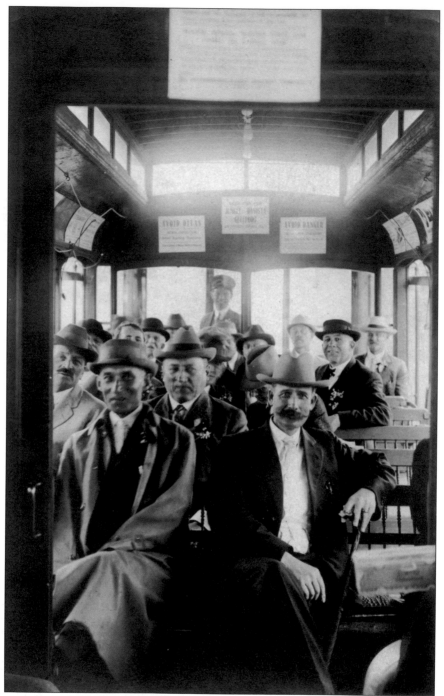

Connecting the St. Petersburg waterfront by trolley to the southern end of the peninsula enabled Frank Davis to sell more land to prospective homeowners. The trolleys were used for daily commuting as well as for parcel deliveries to small businesses and shops along the route. However, all of the schemes did not pay off. Davis had teamed with Civil War veteran Frank Chase in a failed development of an area they called Veteran City. The site was later known as Disston City and, still later, by its current name, Gulfport.

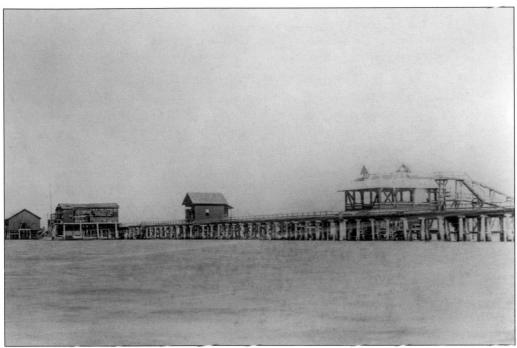

One of Florida's most important industries, the shipping of fresh fish, began when Henry Hibbs leased a shed from the Atlantic Coast Line and started his fishing business. Establishment of the Crystal Ice Manufacturing Company made the industry possible. Visible at right in this 1905 photograph is the innovative sail-powered flatcar used deliver ice to rail cars and fishing boats.

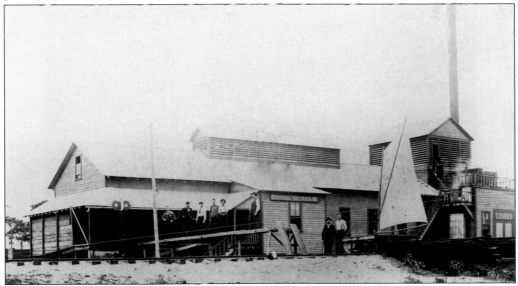

With a retail store in the center of town, the Henry Hibbs Fish & Oyster Company enjoyed a business reputation second to none. The packinghouse became the largest on Florida's west coast, providing employment for nearly 300 people from Clearwater to Sarasota Bay. Journalist William L. Straub wrote that, on one occasion, Hibbs Company packing crews worked continuously for 36 hours, off loading 125,000 pounds of mackerel. An estimated equal amount had to be thrown away, because there was no more ice to preserve the catch.

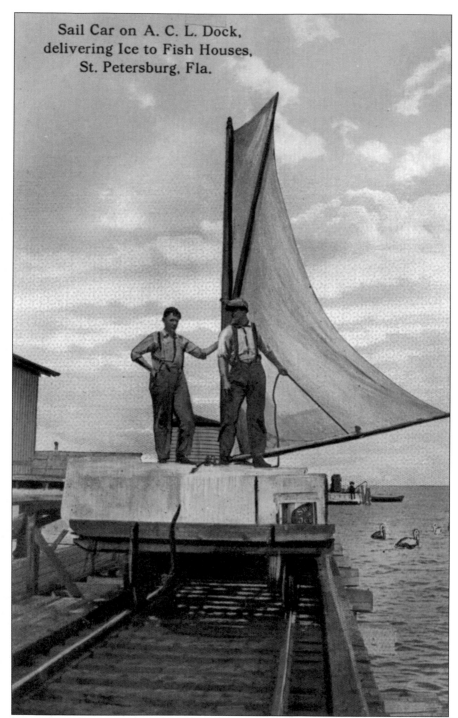

Sail Car on A. C. L. Dock, delivering Ice to Fish Houses, St. Petersburg, Fla.

W.H. Flagg, from Battle Creek, Michigan, was struck and killed while fishing by this sail-powered railroad ice cart operated in 1913 by the Hibbs Fishing Company. Fishing from the railroad section of the pier was not allowed, but that rule was rarely enforced. Following the unusual accident, Hibbs stopped using the wind-driven flattop car, resuming the earlier practice of smaller ice carts pulled by mules.

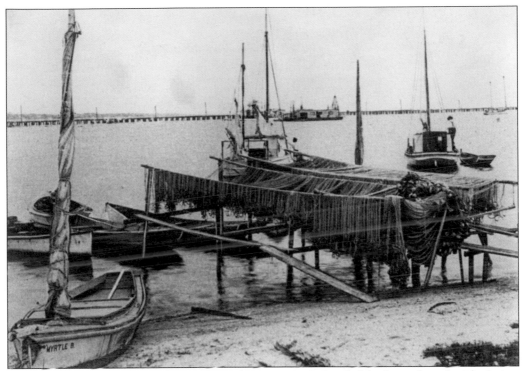

By about 1908, the municipal waterfront was, in a word, "trashy" looking, dotted with drying fishnets, makeshift repair yards, abandoned fishing skiffs, and city debris. The Electric Pier can be seen in the background.

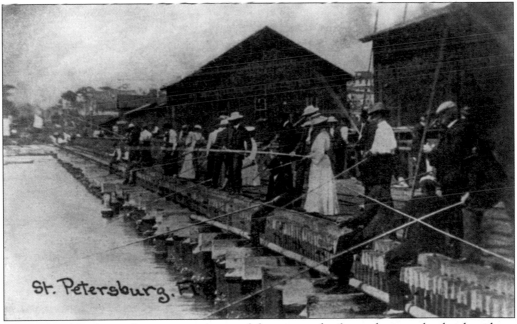

The Railroad Pier's initial purpose was to extend the water and rail cargo business, but local residents quickly recognized the fishing opportunities presented to them. With rented warehouse structures seen behind them, these folks had no problem ignoring the "No Fishing" signs in 1910.

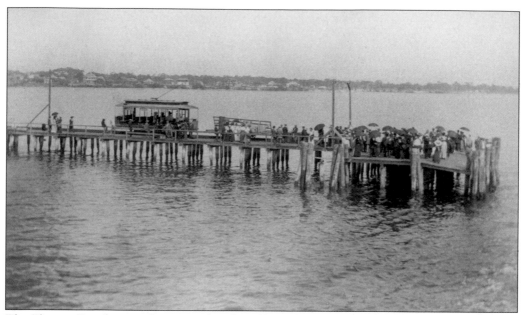

The Electric Pier frequently swarmed with trolley riders waiting with baggage in hand for an excursion boat to arrive. Daily trips ventured not only to Tampa, but Pass-a-Grille, Egmont Key, and Clearwater. Soon, longer voyages to Key West and Cuba were added to the schedule. Newspaper advertisements hawked round-trip fares between St. Petersburg and Tampa for as little as 50¢ one way; special $2 dinner cruises were also offered. The steamer *Margaret* was one of the popular passenger vessels of the time. Competition for docking fees and mooring charges would force the construction of piers built only 10 feet apart. The city built a footbridge between two piers to accommodate local fisherman.

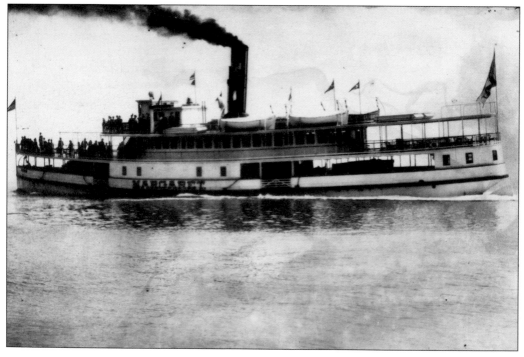

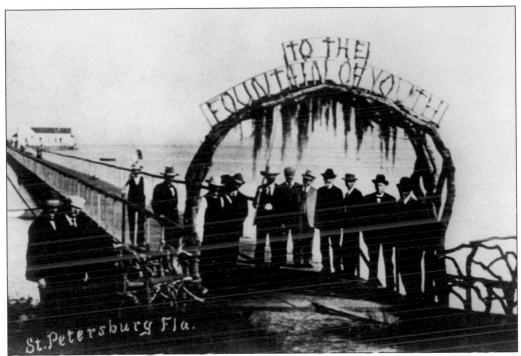

St. Petersburg Fla.

In 1908, Dr. J.F. Conrad bought the Fountain of Youth from the Edwin Tomlinson family and dispatched J.E. Newhouse to manage the revamped bathhouse. Neither man was a stranger to the mineral bath mystique. Since 1880, Newhouse and Conrad had been operating the Magnetic Springs Baths, known to have unusual magnetizing waters. Each summer, the tiny Ohio village of barely 300 residents was invaded by as many as 10,000 visitors seeking the water's alleged curative powers. Conrad hoped the Fountain of Youth would have similar success in Florida. Medical advances following World War II led to the decline in popularity of both facilities.

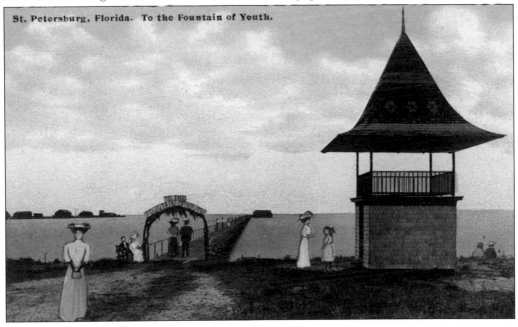

St. Petersburg, Florida. To the Fountain of Youth.

With his back turned to the Railroad Pier, this unidentified lad surveys the Vinoy Hotel, which opened in 1925. The calm basin waters give little hint of the arguments and turmoil surrounding the city's waterfront development. Investor and developer C. Perry Snell gave nearly 25 acres of shoreline and low-tide property to the city, provided it be used exclusively for park areas. Bridge builder George Gandy Sr. lambasted the city council for allowing dredging in the area, claiming it would become stagnant and foul. But more turmoil would follow, as the Sunshine City became seriously involved in the business of piers.

Two

BOOM TIME
1913–1926

The December 1913 opening of St. Petersburg's Recreational Pier attracted a sizeable crowd, but nothing compared to an event just two weeks later. On January 1, 1914, world history was made. At approximately 10:00 a.m., Tony Jannus flew the first ever scheduled commercial airline flight from St. Petersburg, crossing the bay and landing in Tampa. The 22-minute trip was revolutionary, as other modes of transportation could take hours to span the bay. Publicity had city fathers flying high, but even more headlines would dominate that spring, as the city was about to enter the major leagues, thanks to Albert Fielding Lang.

Lang, originally from Pennsylvania, tried to get the Pittsburgh Pirates to train here in 1912, but he was quickly turned down. Fearless of striking out, he convinced the manager of the St. Louis Browns to bring his team to the Sunshine City. The first game against the Cubs, who traveled from Tampa by boat, was played in Coffee Pot Park. That game secured Lang's title of "Ambassador of Baseball" and etched St. Pete's role in baseball history. His contributions to the city would continue in other ways as well.

As mayor two years later, Lang instituted an ordinance that all benches, which had been popping up on Central Avenue for several years, be uniform in shape, size, and color. For the next 40 years, the Green Benches were known worldwide.

As the Roaring Twenties ushered in a major real-estate boom throughout Florida, and certainly in St. Petersburg, Mother Nature joined in. On October 25, 1921, a Gulf Coast hurricane ravaged the Pinellas Peninsula. Damage to the waterfront and the piers was extensive. Nearly every pier was destroyed. Yet, like a Phoenix rising from the ashes, the city quickly rebounded, rebuilt, and beckoned northern visitors.

Within weeks, civic leaders pushed for a grander replacement of the beloved Recreational Pier. The years of pier wars were over. No longer would the waterfront play host to the noxious shipyard smokestacks or the visual blight of other bay industries. St. Pete was determined to embrace its shores as a public commodity for all to use.

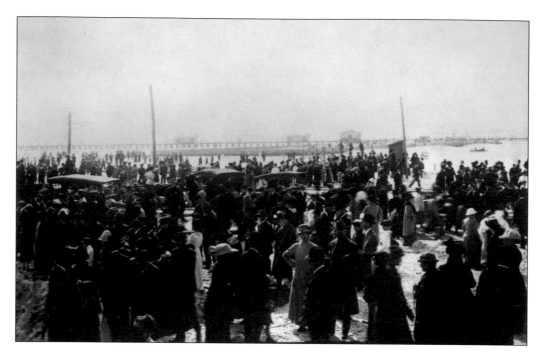

Spa Beach, the Municipal Pier, and most places along the waterfront were packed with spectators hoping to get a glimpse of Tony Jannus piloting his bi-wing airplane over the bay. It was New Year's Day, 1914, and the official start of regular scheduled air-passenger service—the world's first airline. With former mayor Abe Pheil aboard, the flight to Tampa took 23 minutes, the return trip slightly less. Even though the air service was not as profitable as hoped, it paved the way for today's billion-dollar industry. Jannus would fly his Benoist airplane over Tampa Bay for about three months with a perfect safety record.

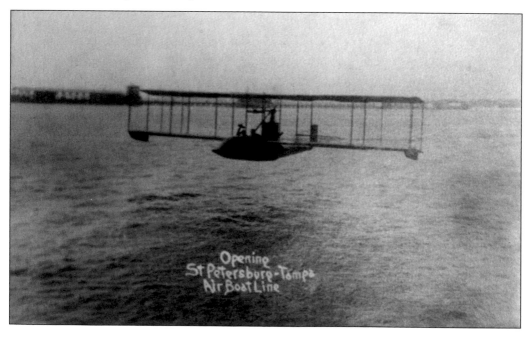

Opening
St Petersburg-Tampa
Air Boat Line

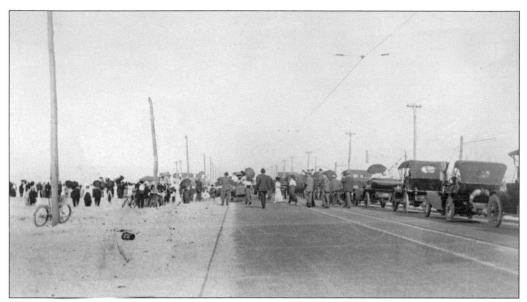

The city had not taken official ownership of the new Municipal Pier, but in mid-December 1915, hundreds of winter visitors and locals were given a sneak peek of the "magnificent new wooden structure at the foot of Second Avenue North and almost immediately adjacent to the former site of the city's Electric Pier."

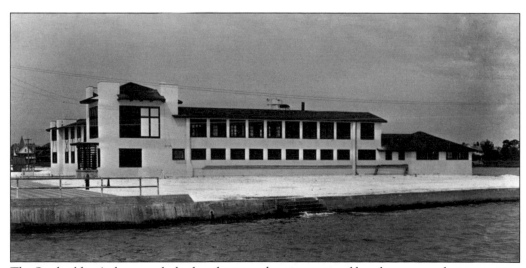

The Spa building's three pools, baths, playground equipment, and beach access made it an instant hit with folks visiting the pier and its approach.

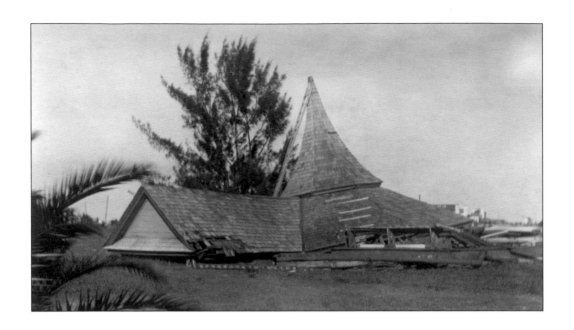

With recorded sustained winds of 68 miles an hour, the storm that hit Pinellas County on October 25, 1921, technically fails to qualify as a hurricane. But, to those who were there, the torrential wind and rain was fierce, damaging much of St. Petersburg's waterfront. Tomlinson's Fountain of Youth pier was the first to go (above). Only a few pilings remained where the Municipal Pier stood. The Hibbs Fish Company building and the water tank were the only survivors along the devastated Railroad Pier. The yacht club building was a temporary island (below). The Detroit Hotel suffered an estimated $10,000 in damage; the Spa bathing pavilion was a complete loss, valued at 10 times that amount.

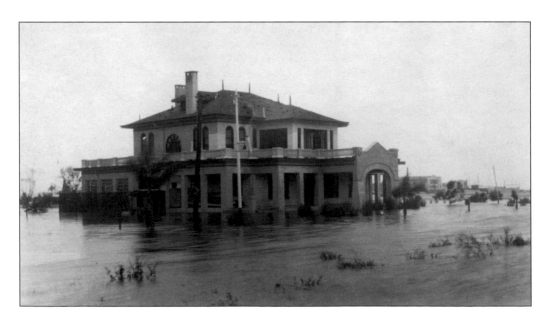

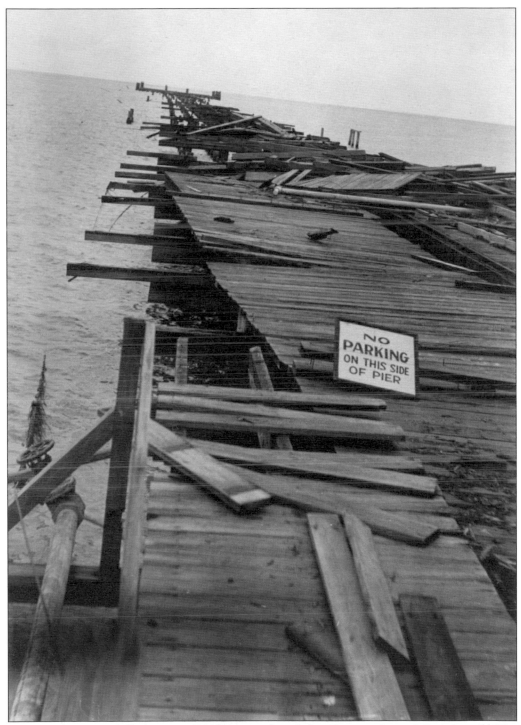

The 1921 hurricane killed seven of Hibbs's men aboard the schooner *Agnes Bell* in the gulf. The ACL pier was devastated, but some of the Hibbs equipment survived. "Winds smacked the water clear over the pier," writes local historian Scott Hartzell. Later, the company would lose nine crewmen on a schooner that was struck and destroyed by lightning.

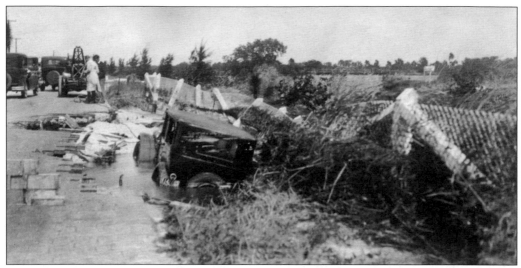

Area residents quickly assessed the storm damage as unfounded rumors of death and destruction began to circulate. Fortunately, the city recorded only three deaths on land as a result of the storm. While it is correct to say that every school building sustained damage and the waterfront was hard hit, the final result was a new, optimistic attitude among boosters and developers.

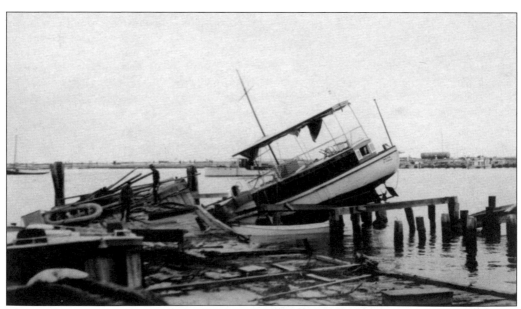

The Bayboro Harbor Coast Guard radio antenna was knocked out by the hurricane, and Western Union connections were severed. News of the storm was sent to "the outside world" by rail. Tuesday night, as the wind and rain subsided, an ACL passenger train headed north with a Western Union employee carrying more than 400 telegrams and instructions to transmit them at the earliest working telegraph point, which turned out to be Jacksonville.

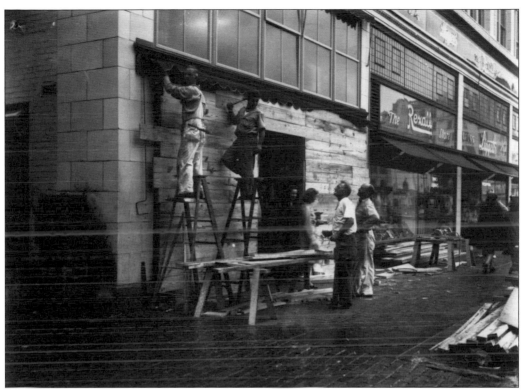

While citizens quickly set about to repair storm damage, two special, four-page issues of the *Times* hit the streets early Wednesday morning, October 26. The newspaper maintained its record of never having missed an issue intact. With power lines down, printers rigged up a borrowed motorcycle to run the linotype machine and operated presses by hand to meet the deadline. Even as folks are accessing the piers and waterfront damage, boosters were quick to respond. Local legend has it that, following the storm of 1921, newspaper publisher Lew B. Brown rallied the community by issuing the challenge, "Let's build a million dollar pier." Amazingly, the Million Dollar Pier came in under budget, according to Walter Fuller, at $998,729.18. The rounded-up number had a more impressive promotional sound to it.

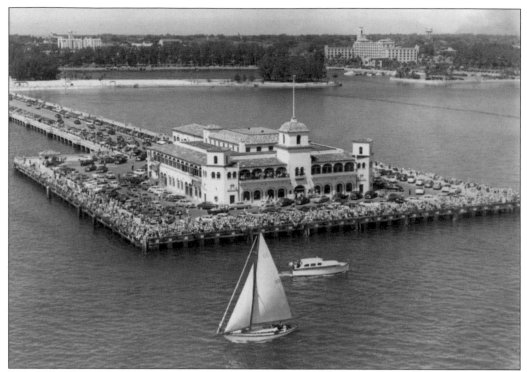

Opening-day activities took place on Thanksgiving Day 1926, introducing the public to the impressive Million Dollar Pier and Casino. City council members received their inaugural bill, for a routine series of maintenance expenses. During the grand opening, some clay roof tiles of the Mediterranean-style building were broken by spectators walking on them, presumably for a better view. Damages totaled about $100, and rooftop "No Trespassing" notices were posted.

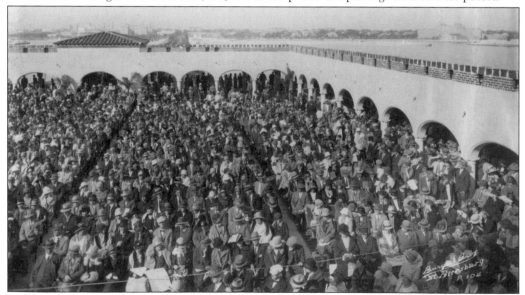

Thousands of visitors packed the new Million Dollar Pier and its open-air ballroom on opening day. At the formal dedication, Mayor R.S. Pearce declared, "To pleasure; clean pleasure for the benefit of body and soul, this pier is dedicated."

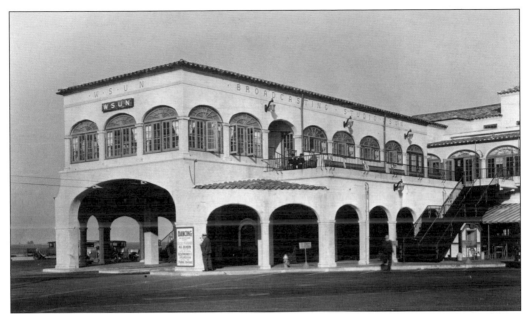

The second-floor Shrine Club at the pier casino was a busy place in July 1927, when WSUN radio began broadcasting three nights a week from its new $40,000 studios. The St. Petersburg Chamber of Commerce partnered with the Clearwater Chamber of Commerce in owning and operating the area's first broadcasting facility. The shared-frequency deal allowed both communities to broadcast local programs on alternating Sundays. Promoters claimed the WSUN call letters stood for "Why Stay Up North?"

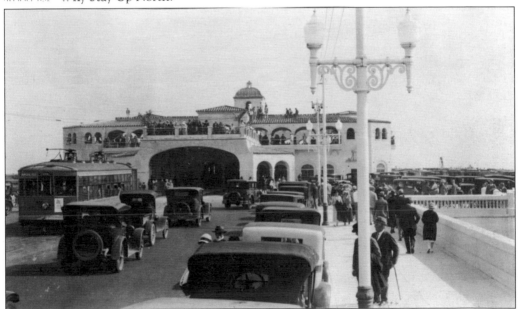

Even with warmer summer temperatures, the pier was a main attraction. With its studios just inside the Mediterranean-style casino, WSUN radio attracted a listening audience by using strategically positioned outdoor speakers. Automobile drivers "just out for a cruise" would parade around the building and back to shore on a frequent basis. In May 1930 alone, more than 82,000 cars made the trek.

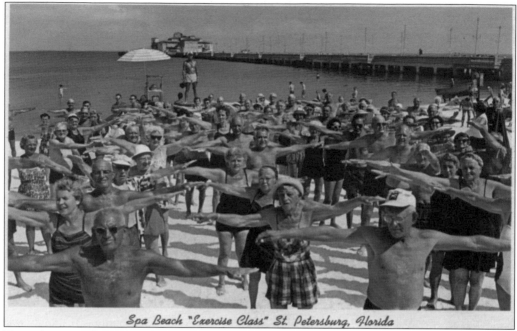

Spa Beach "Exercise Class" St. Petersburg, Florida

Every day at 10:30 a.m. and 2:30 p.m., the City Advertising and Library Board provided group calisthenics as one of the many Spa Beach attraction activities near the Municipal Pier. Sun worshipers not only had access to the beach and pier approach, they could also swim in one of three indoor pools at the spa, take swimming lessons, and sunbathe.

At the Spa, men and women could soak up rays in same-sex tanning bed areas, separated by a 15-foot wall for privacy. Convenient parking was available on the pier and nearby. Snack bars, concessions, and shops completed the pier approach.

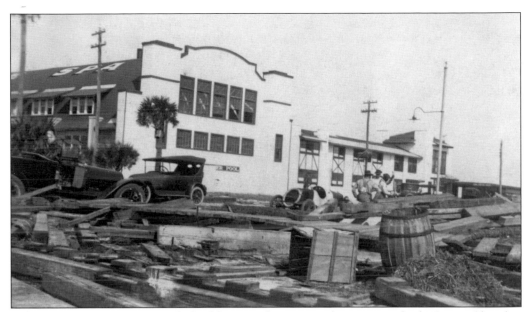

Following extensive repairs to the buildings on the municipal pier approach, the Junior Chamber of Commerce saw the need to update the "senior citizen" image of St. Petersburg. An attempt was made to attract new visitors, residents, and their dollars. The Jaycees leased property along the Municipal Pier, close to Spa Beach, to build its clubhouse and headquarters. Special young-adult activities were held throughout the tourist season.

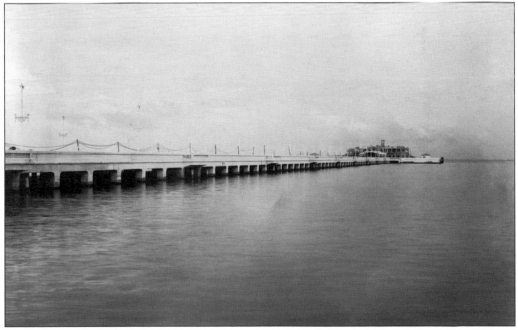

Capt. G.L. Roberts had day-to-day management responsibility for the pier for about six years beginning in 1928. He was said to run the concrete peninsula with "military efficiency," posting a daily repair and maintenance log; maintaining tide, temperature, and barometric pressure readings; and scheduling rentals and private events. From June 1929 to the following June, over one million people were entertained in some fashion on the pier, according to published reports.

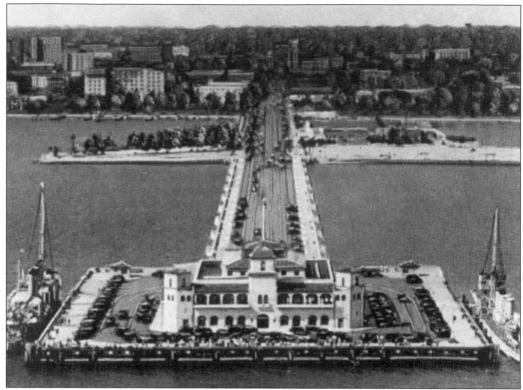

The Coast Guard regularly docked ships on the north and south sides of the Million Dollar Pier head, while the western approach was usually available for privately owned yachts. The recreation pier was taken over by Seminole Indians for a week in 1937. The friendly occupation was part of an exhibit on Florida history. Social groups like the Our Gang sewing circle frequently met to chat and make quilts. Card games were a favored form of entertainment between state clubs. The 1928 society pages hinted that members of the ladies auxiliary of St. Pete's Master Plumbers Association were the toughest, most no-nonsense bridge players around. In 1929, Eastern Star women filled 100 tables, the largest card night on record.

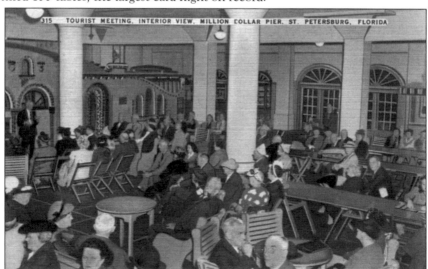

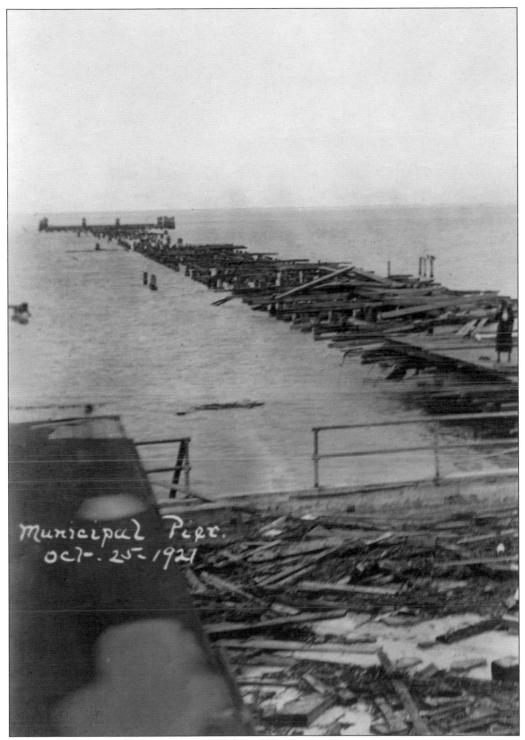

It is impressive how the extensive damage along the Municipal Pier (pictured) was rapidly transformed into the Million Dollar Pier and Casino. From destruction to an icon seen around the world, the results were amazing.

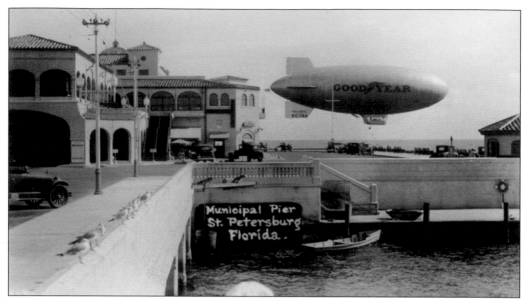

Municipal marketing genius John Lodwick, a former Ohio sportswriter, struck a deal with his Akron pals to bring a Goodyear blimp to St. Petersburg. The city built a new blimp hangar at Albert Whitted Airport, and the dirigible delighted residents and visitors alike, offering $10 rides over the bay. However, Lodwick's optimistic prediction that "thousands would travel daily" by way of the gas-filled flying machines never materialized.

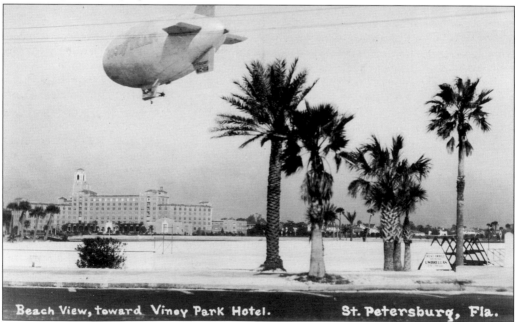

Beach View, toward Vinoy Park Hotel. St. Petersburg, Fla.

Lodwick's only other "failure" in promoting St. Petersburg came when he arranged for the National Association of Realtors to hold its convention in the Sunshine City. It rained all weekend. The realtors received free newspapers from publisher Lew Brown, thanks to his famous Sunshine offer. Somehow, the land salesmen returned home even more enthused about the Million Dollar Pier, the waterfront, and St. Pete's profit possibilities. Like a city becoming a permanent home to a Goodyear blimp, those hopes would soon be dashed, however.

Three

Depression and World War II
1926–1941

The Million Dollar Pier opened on Thanksgiving Day 1926 to a crowd of 10,000. From card games and sing-alongs to the jitterbug and slow dances in the open-air ballroom, the pier was a hit. While trolleys ran down the pier, hundreds of fishing poles could be seen daily, cast into the mackerel-riddled waters. The city of St. Petersburg was bursting with pride and even more growth.

During the 1920s real-estate boom, the city experienced a massive population growth. Developers took advantage of thousands of acres of undeveloped land to create several distinct housing subdivisions. Other investors focused on the hotel industry to accommodate the influx.

By the time of the Million Dollar Pier's opening, St. Petersburg witnessed the construction of 10 large hotels, including the Vinoy. Within the year, however, St. Petersburg's construction and land speculation all but disappeared. The boom had gone bust. Although a minor population exodus occurred, the tourist trade continued as northern investors and visitors rode Wall Street all the way to the 1929 Great Depression.

Not all construction halted after the speculation bust. St. Petersburg's declaration of an industry-free waterfront created much activity a few miles southward, with Bayboro harbor improvements and a blimp hangar at nearby Albert Whitted Airfield paving the way.

From 1929 to 1939, various Goodyear blimps called St. Petersburg home. The lighter-than-air flying machines seemed like a great tourist promotion. The baby zeppelins gave the Sunshine City national coverage and tourists $10 rides over the city. The blimps even played a role in the inauguration of airmail service from St. Petersburg to the rest of the world. A small bundle of Air Mail letters was hoisted from the downtown post office building by a blimp and delivered to an awaiting airplane at the new Piper-Fuller Airfield, today's site of Admiral Farragut Academy.

Over the next decade, dirigibles with names like *Mayflower*, *Puritan*, and *Reliance* soared over the city's beloved Million Dollar Pier and were a common sight in St. Pete's skyline, even as war loomed on the horizon.

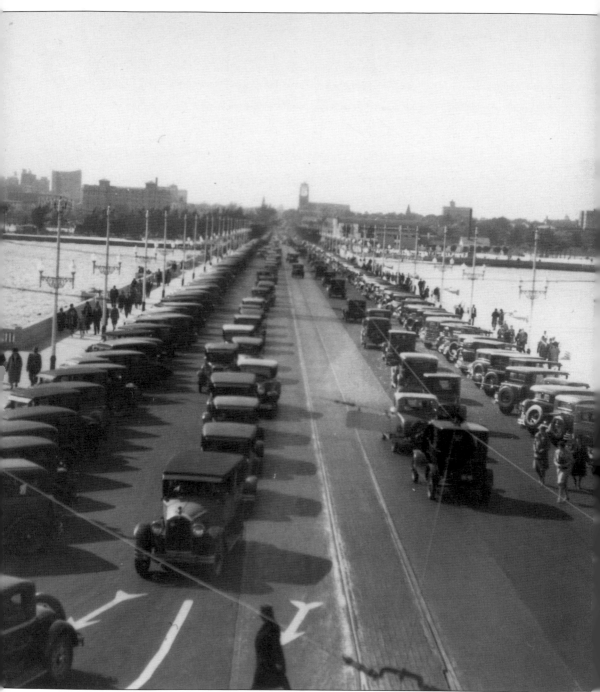

At the height of the 1929 tourist season, as many as 7,000 cars a day drove to the Million Dollar Pier, parked, or circled the casino. Guest registration books list tourists from every state in the union visiting the pier from July 1928 to January 1929. Throw in a few Englishmen, a handful of Canadians, and folks from a few other countries, and one has the makings of an international melting pot.

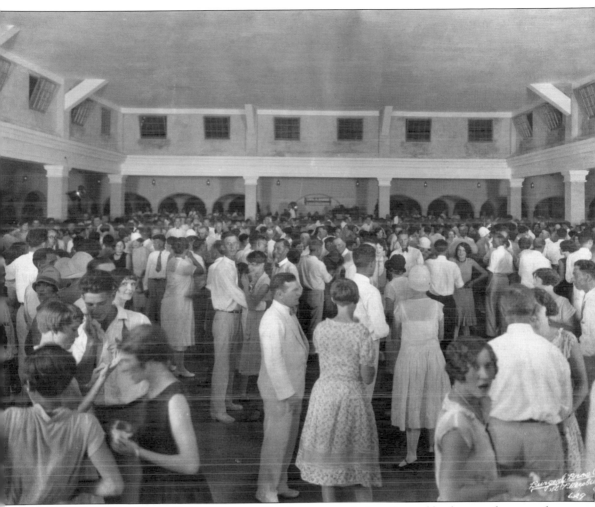

The casino dance hall and theater stage offered accommodations favored by dozens of state and national associations. Among these groups was the Tile and Mantel Contractors Association of America, 500 members of which assembled on the pier for its silver jubilee. Casino operators bragged about the spectacular view of the bay and were equally proud of the building's interior design. Deep tan- and ivory-colored walls were accented by a combination of blue and sunset-orange curtains. Original "Songs of St. Petersburg" were featured at the weekly community sing on the recreation pier in 1929. Most were written by visiting snowbirds and always enlivened the spring musical welcoming ritual. A composition by Lillian Bridgham of Waverly, Massachusetts, set to the popular George M. Cohan wartime tune "Over There" was a favorite: "On the Pier. The Sunshine pier. There, our troubles and our cares disappear. / With the sun a-shining the silver lining of clouds shows wondrous, bright and clear!"

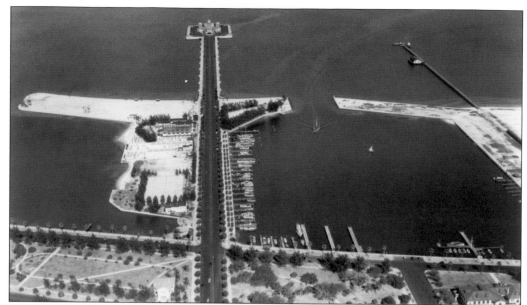

The Million Dollar Pier helped St. Petersburg live up to its reputation as a city of promoters and pitchmen. In August 1927, the Smith Motor Company offered a used Harley Davidson motorcycle to be driven by a daredevil off the Million Dollar Pier and onto the deck of a boat. The feat was proposed by Pathé News photographer Ralph Earie as part of a series of stunts filmed with Sunshine City backgrounds. The ACL pier can be seen on the far right.

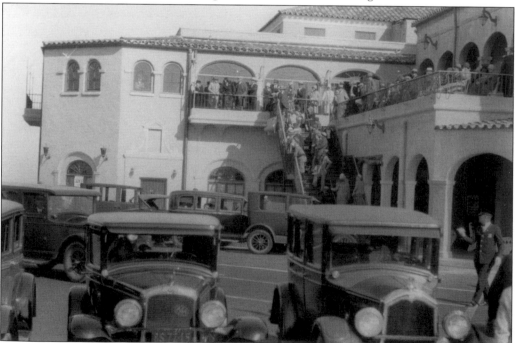

As the Great Depression gripped the nation, the *Sunshine and Shadow* weekly radio broadcast on WSUN encouraged listeners to bring in unwanted items of clothing and furniture to share with the needy. Sponsored by the Civitan men's organization (women are today included), the afternoon program frequently attracted throngs of community-minded citizens with their donations.

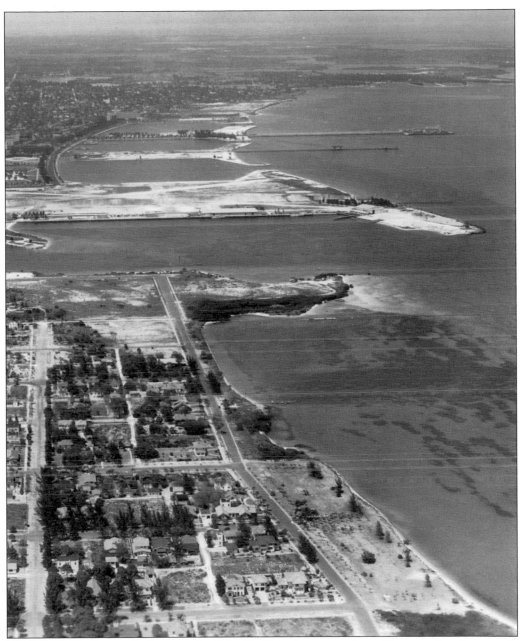

This north-facing aerial photograph of the St. Petersburg waterfront illustrates just how much dredging, landfill, and seawall took place along the original, relatively uninterrupted shoreline. At lower right is Lassing Park, property that today remains virtually unchanged because of restrictions placed on it by the donor, Judge Robert B. Lassing. He stipulated in 1924 that his gift to the city would have "no buildings other than necessary for park purposes." The water here is very shallow, but fishermen and swimmers have occasionally experienced strong and dangerous riptides. At the center of the photograph is Bayboro Harbor, in the early development stages as the maritime training center and Port of St. Petersburg. Albert Whitted Airport is the large area just above center (note the large blimp hangar on the western edge of the property). Demens's landing is further north, followed near the top with the 2,000-foot-long Municipal Pier.

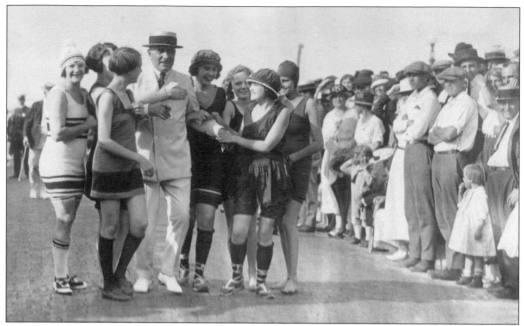

While large cities such as Miami and Tampa relied on industries ranging from shipping to citrus production, many other seaside communities were fairly industry-free. Instead of smokestacks emitting noxious fumes on the waterfront, the city of St. Petersburg embraced green landscapes and unobstructed views. The city sold its sand, sun, and surf. And so did its residents. From Mayor Frank Pulver to William Carpenter, there were plenty of residents more than eager to sell the Sunshine City. Pulver (above), dressed from head to toe in white, was known to travel to his home state of New York with a handful of bathing beauties and parade down the streets, encouraging folks to visit St. Petersburg. His counterpart, William Carpenter, traveled the United States with his alligator, named Trouble. He handed out city brochures and encouraged onlookers to "Follow me to St. Pete!"

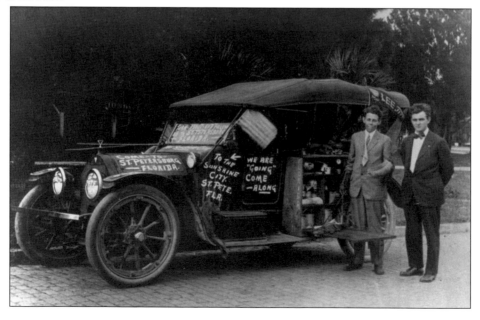

The St. Petersburg-to-Havana yacht race was an ideal sporting event for a wide audience. The authentic nautical crowd liked the event for the thrill of challenging the open waters on a nearly 300-mile course. For those who preferred to hang with the right crowd, smoke cigars, and drink good Cuban rum, the finish line was the place to be. And for the uninitiated landlubber who did not know a spinnaker from a halyard, the start of the race at the Million Dollar Pier was a true spectacle.

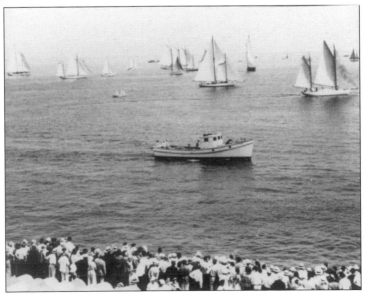

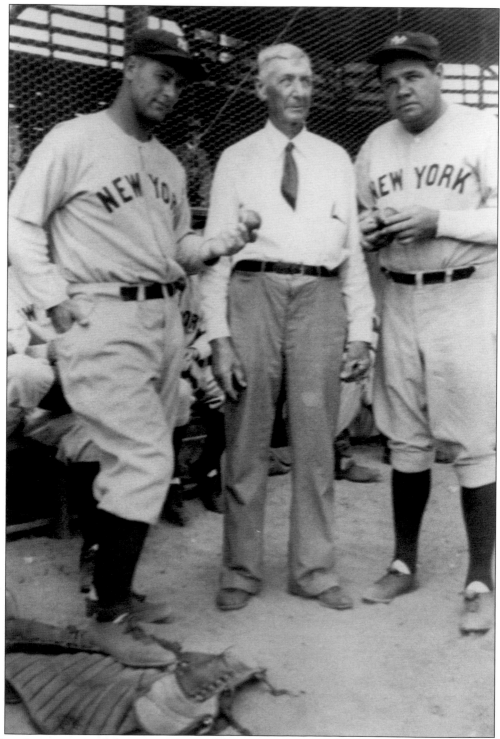

Seen here are two of the most recognizable names in sports, Lou Gehrig (left) and Babe Ruth (right). They helped put St. Petersburg on the map as far as baseball fans are concerned. Dick Mayes (center) presents Gehrig and Ruth with baseballs from his early career.

Babe Ruth, seen here about 1933, was noted for his alleged refusal to practice at the Crescent Lake field, about a mile from downtown. He was convinced that the marshy grounds were swarming with alligators and is reported to have said, "a $2.00 baseball just ain't worth it."

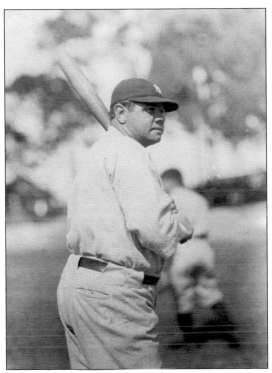

Good crowds always turned out when the New York Yankees played training games at the waterfront ballpark. St. Pete's own "Ambassador of Baseball," Al Lang would have this field named after him in later years. Convincing hall-of-fame manager Branch Rickey to bring his St. Louis team to St. Petersburg led to a long tradition of Sunshine City spring training activity. Rickey, incidentally, is credited with inventing the batting helmet.

In the above photograph, the Vinoy Hotel serves as a backdrop for the newly dredged marina basin and reinforced concrete seawall near Spa Beach. Residents and guests could swim, enjoy the cabana-like shade structures, or just stroll around the area. On the opposite side of the pier, away from bathers, powerboat races (below) were always popular and exciting.

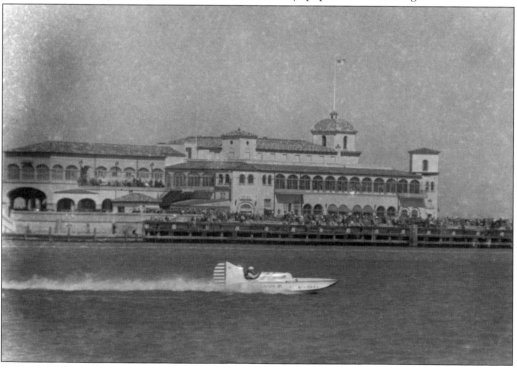

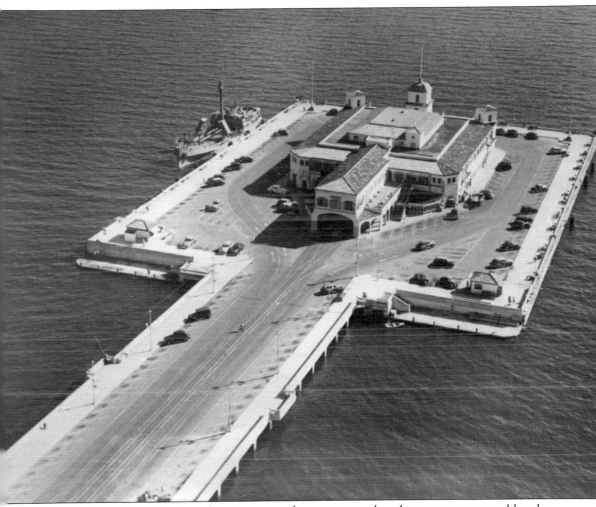

In 1934, the trolley rails along the pier approach were removed so that street crews could make needed pavement repairs. The city council argued that buses would be a better form of transportation to and from the casino, but engineers and city manager Carlton Sharpe won out, saying the pier was designed for a street-rail system and was a tourist attraction in its own right. Following the street repair work, the rails and trolleys returned.

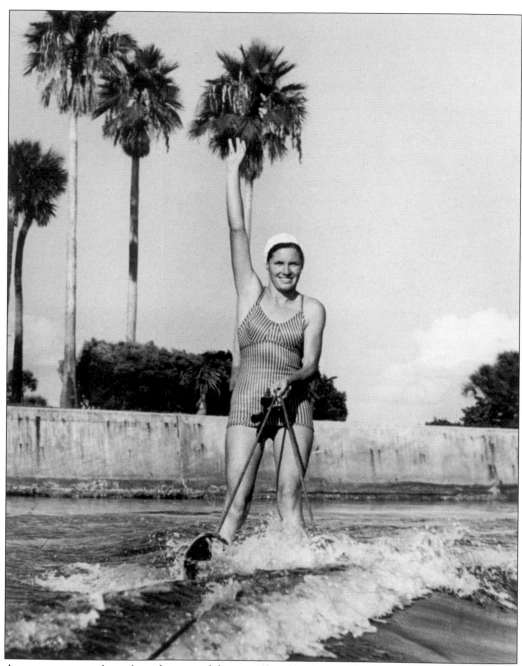

A newspaper weather editor discovered dozens of local bathers at Spa Beach relaxing in the shade of the big pilings of the Municipal Pier and proclaimed the pier to be "the coolest place in town." Marylois Brown probably agreed, but here, she clearly illustrates that waterskiing near the new seawall was pretty cool, too.

The luxurious Don CeSar Hotel on St. Pete Beach was put into service as a rehabilitation facility for returning airmen and pilots suffering from combat fatigue, shell shock, or combat exhaustion—all names for what is now known as Post Traumatic Stress Disorder (PTSD). Among other less polite monikers, patients nicknamed the Don "the Flak Hotel," a reference to enemy aerial attacks on Allied planes.

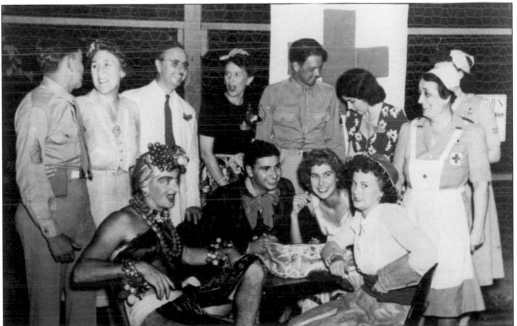

Pilots, visiting relatives, and nurses pose for the camera during a costume party at the Don CeSar. Psychologists and other medical personnel worked tirelessly to help the distraught airmen regain control of their lives.

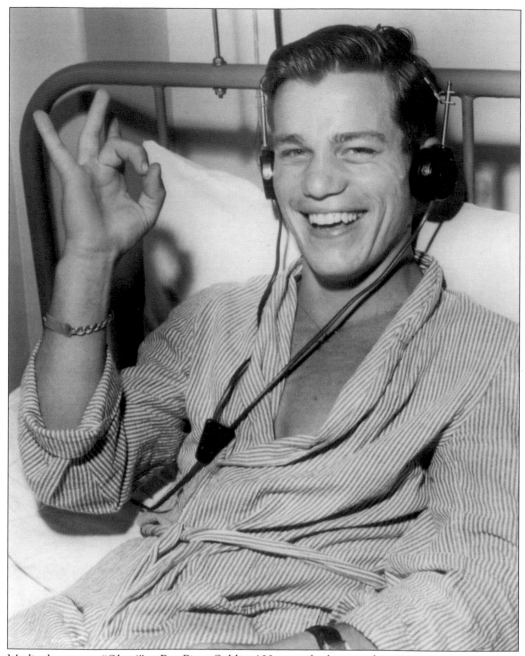

Medical care was "Okay!" at Bay Pines Soldiers' Home, which opened in 1933 as part of Franklin Roosevelt's economic recovery plan. World War II brought a surge in patients, and this required relocating administrative offices to the Don CeSar to gain bed space for patients, like this recovering soldier.

By early 1939, Bayboro Harbor, just south of the city pier and Whitted Airfield, was bustling with activity. The Coast Guard base had been selected as a training center for novice sailors. The two primary training ships were the full-rigged *Joseph Conrad* (lower left) and the more modern *American Seaman* steamer (bottom center). Both vessels made frequent training voyages to Haiti, Jamaica, and Havana.

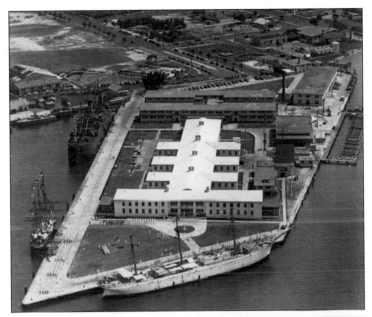

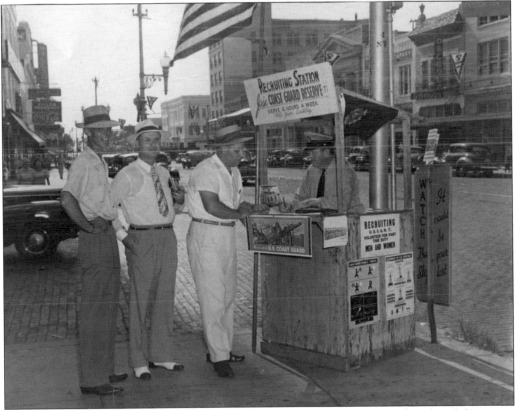

St. Pete's streets, parks, and living spaces were filled with military trainees, but that did not stop Uncle Sam's recruiting effort. Coast Guard recruiters made it easy to sign up, manning street-corner booths in the center of town. A young man could literally sign up on a sidewalk and be off to basic training in a matter of hours.

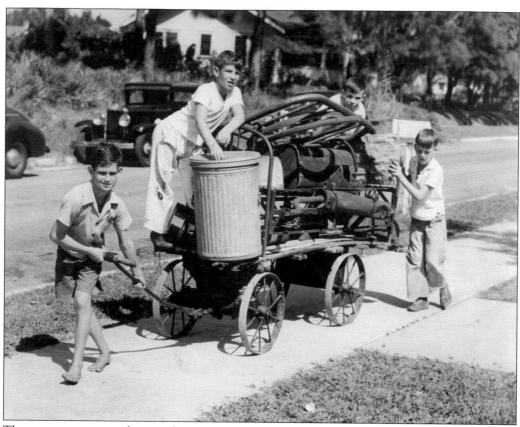

Those too young to volunteer for service helped the war effort in other ways. These energetic kids busied themselves collecting scrap metal (above) and newspaper (below) for recycling. Scouts and various church organizations continued the idea of telephone book and newspaper salvage drives well into the next decade.

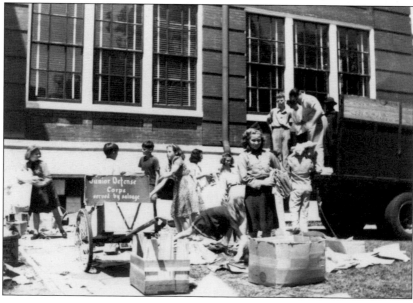

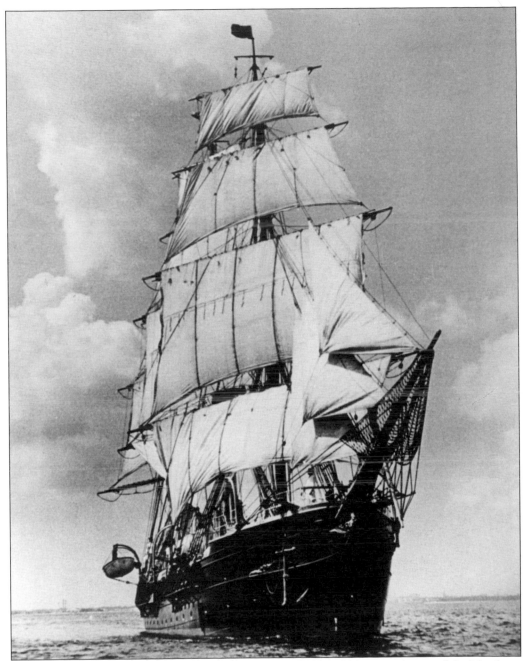

Training aboard the *Joseph Conrad* under full sail was a challenge for any seaman, and the Merchant Marines prided themselves on being among the best. The least-publicized and much-misunderstood service in World War II, its primary mission was protecting Allied transport ships in both the Atlantic and Pacific Oceans. The Merchant Marines lost more than 6,000 men—by percentage, more than any other branch of service.

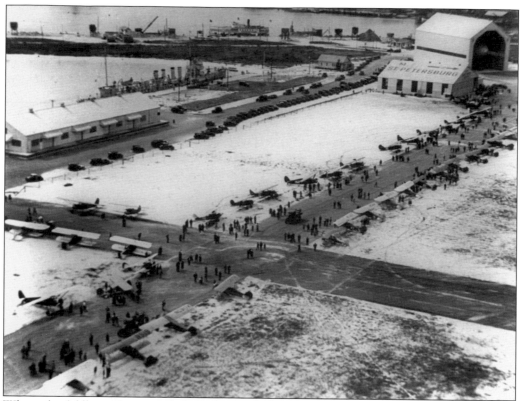

Where the fiddler crab once ruled, dredges and pile drivers were now in charge of transforming Bayboro Harbor (above, background) into a full-fledged naval training center. Albert Whitted Airfield was filled with older World War I aircraft. The new blimp hangar can be seen at right in both photographs.

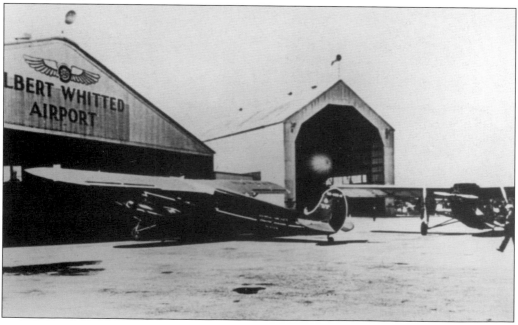

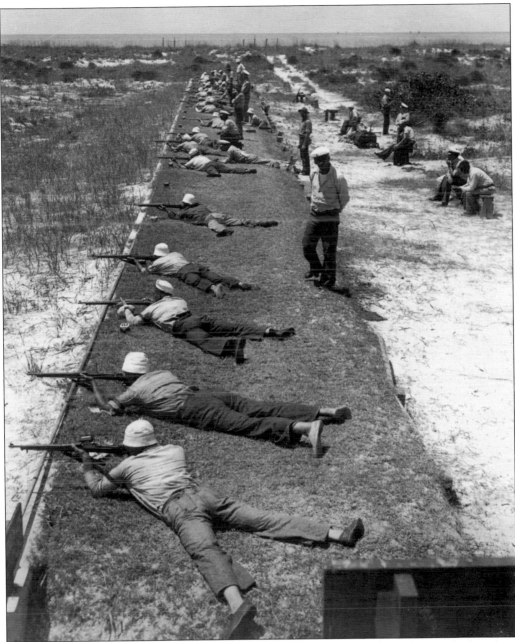

By mid-1941, many of the 25,000 men who trained here were being assigned to sub-chasing ships and airplanes in an all-out effort to thwart the Nazi submarine threat. At one point, German craft came dangerously close to the Atlantic and Gulf Coasts of Florida. Merchant Marine personnel dealt with the hazardous open-sea duty of delivering and protecting sorely needed war supplies.

The training center at Bayboro would ultimately become an important addition to the University of South Florida. But it first trained hundreds of men to man the weapons of war. In all, 172 military installations would occupy the length and width of the state. "Never," notes one historian, "had so many soldiers and sailors landed on sandy beaches, flown over the peninsula, and trained in luxury hotels." Submarine-hunting seaplanes from Bayboro Harbor and other coastal locations helped fend off the daring German "Operation Drumbeat," which successfully sank 24 vessels off Florida's East and Gulf Coasts. And the military trainees for all branches kept coming.

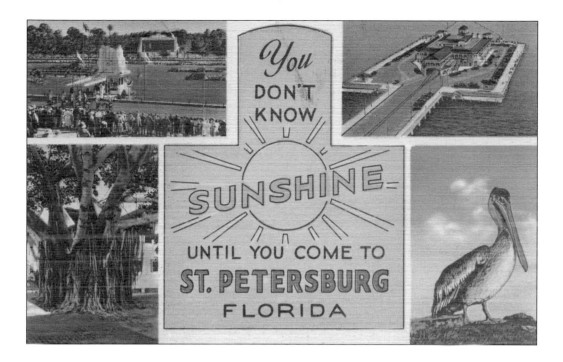

During the Depression, statisticians urged Florida civic leaders to promote their cities as health and wellness centers. Speaking to local advertisers and Kiwanis, Roger Babson stated, "Florida has only one American monopoly— sunshine and climate. Capitalize on those two Florida constants, and Florida will rebound." Local newspapers and postcards were quick to spread this message.

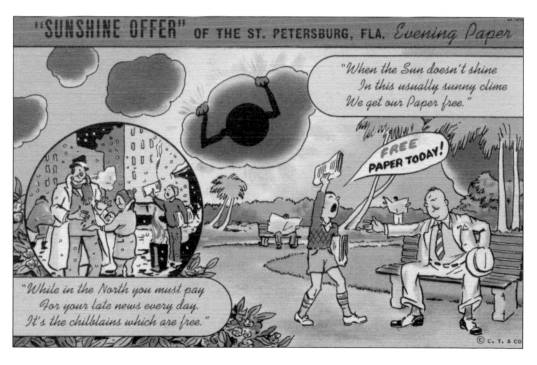

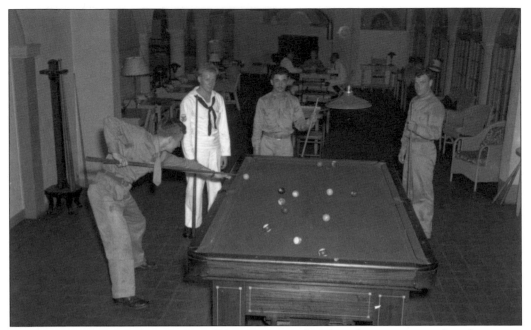

The lucky servicemen who got time off from training played pool, ping-pong, and card games at the pier, enjoyed the beaches, or just walked the streets of downtown, watching the girls. In the afternoons and evenings, the GIs could dance to the music of Jimmy Baker and the Air Corps Orchestra. The guys that were pulling duty could still enjoy the popular musicians live on WSUN radio broadcasts, but only until sunset. In those days, most radio frequencies were allowed to broadcast only from sunup to sundown.

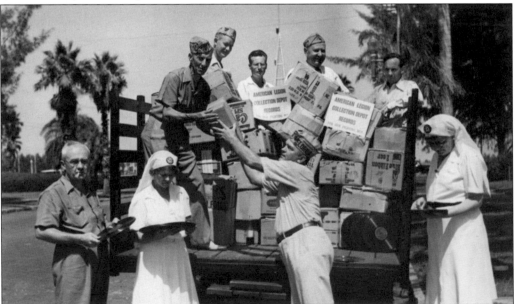

Live music could not be everywhere, so phonograph records were one of the items the American Red Cross sent to soldiers and airmen stationed overseas. Off-duty trainees and American Legion volunteers organized collection drives to build the inventory in Army base day rooms and even for broadcast on Armed Forces Radio.

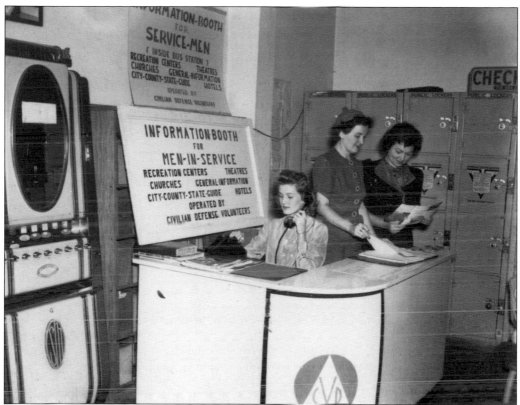

Civilian Defense volunteers across the city were prepared to help make the thousands of trainees feel as much at home as possible. Information centers, like the one shown above, were strategically located near the center of downtown and the railroad depot. Arriving soldiers could find out about churches, entertainment, and other helpful information. Below, a kiosk run by the Army Officers Wives Club was one of the many ways war bonds were sold to the public. Celebrities, returning war heroes, school kids, and everyday citizens joined in the cause, raising hundreds of thousands of dollars.

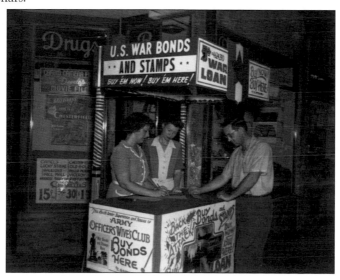

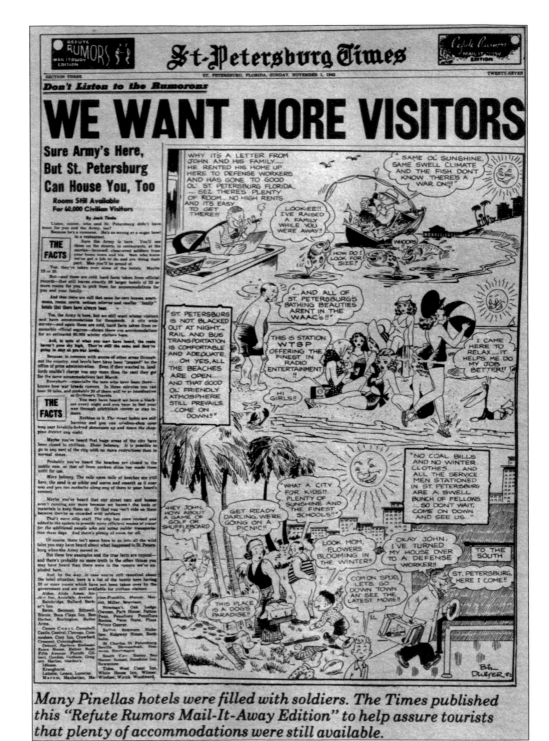

Many Pinellas hotels were filled with soldiers. The Times published this "Refute Rumors Mail-It-Away Edition" to help assure tourists that plenty of accommodations were still available.

Following the Great Depression, pending war restrictions nearly delivered a knockout blow to the Sunshine City. War, continents away, threatened to destroy the very fabric of St. Petersburg's tourist-dependent economy. National advertisements in the *St. Petersburg Times* continued to remind folks that the city was still open for business.

Four

WAR AND PROSPERITY
1941–1967

Although wartime conditions halted local tourism, the city of St. Petersburg housed well over 100,000 war-related personnel by 1943. Nearly every motel, hotel, and boardinghouse was converted to billeting these wartime soldiers, sailors, pilots, trainees, wives, and other support personnel. Every major downtown hotel, except for the Suwannee, was converted for military usage.

Citizens responded to the call of duty by holding scrap-metal and recycling campaigns. One such event netted over 250 tons of metal for the war effort. While the beaches and local haunts were now a major source of relaxation for visiting GIs, the Million Dollar Pier became a favorite spot for service members.

Following the war, St. Petersburg returned to its resort-community status. Armed with GI Bills for education and housing, military folks who had trained in the tropical climes of the Sunshine City returned as residents and visitors. The city experienced one of the largest housing and population growths in its history.

Former training facilities were converted into commercial use. The Pinellas Army Air Base now operates as the St. Petersburg-Clearwater International Airport, while the area around the Bayboro area became the Port of St. Petersburg and the University of South Florida–St. Petersburg.

The much-anticipated Sunshine Skyway Bridge from St. Petersburg to Manatee County opened in 1954. The following year, seven African Americans attempted to use the facilities at Spa Beach. Access was denied, based on city policy. This resulted in a federal lawsuit requiring beach and pool integration. The city responded by closing the facility. In 1959, buckling under pressure by the business community and declining tourism, Spa Beach and the pool reopened to all citizens.

The 1960s brought social justice and civil rights to the fore. Lunch counter sit-ins, sanitation strikes, and business boycotts were held for equal rights. Attempts were begun to revitalize the downtown core and encourage a younger population to return, while the famed Green Benches were slowly removed from the city in an effort to eliminate the visible presence of retirees. And, to the dismay of many, the Million Dollar Pier was targeted for demolition.

With war rationing in effect and local tourism at a standstill, director of recreation P.V. Gahan (above, left) and million-dollar pier manager John Gough (above, right) were among many who sought ways to fill the pier's empty clubhouses (below) and the city's vacant hotel rooms. In special editions, both the *Times* and the *Evening Independent* urged tourists to come to St. Petersburg as part of the war effort. The rationale was that, for every family who left the Northeastern states to spend the winter in Florida, hundreds of gallons of precious fuel oil would become available for the nation's war machine. To avoid potential criticism, the newspapers were savvy enough to also urge readers to share these special editions and conserver paper.

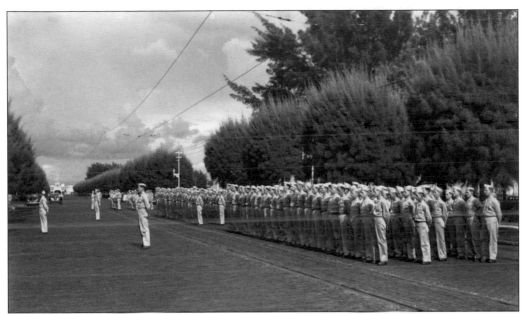

By October 1942, US troops were fighting difficult battles in the Solomon Islands With a lowered draft age bill pending in the Senate, thousands of young soldiers continued their training throughout Florida and in St. Petersburg. The theater stage of the Municipal Pier was the setting for Army-produced talent shows, providing a break in training for the young soldiers. Pvt. Andrew Zurine of Simpson, Pennsylvania, stole the show at one particular packed-house performance with an accordion solo. Still in his teens, Zurine probably had to wait before using his first-place prize—an electric razor. On the home front, citizens pitched in to support the war effort through rationing of fuels, metals, and meats. Scrap drives collected up thousands of pounds to assist in war-materials production.

Besides hosting many USO activities, there were times, of course when the pier helped inspire romance. Popular St. Petersburg Bomb-a-Dear Betty Tugman received this poem from an admiring soldier who was stationed at Dorr Field in Arcadia and a regular visitor to the pier: "Now each and every evening I go dancing at the pier, / For a truly charming partner, I've a gorgeous Bomb-a-Dear. / A hepcat, really solid, with luscious big brown eyes, / The answer to a dancer's prayer, sent straight from paradise. / But since that very moment on the pier, I haven't been quite sane. / For I've become enchanted by this angel Betty Jane!"

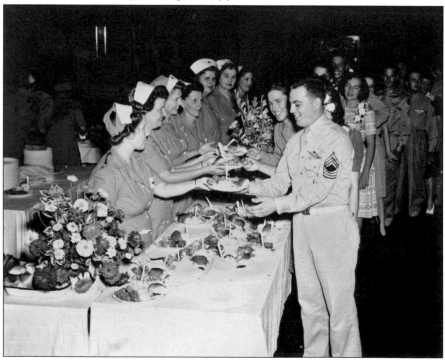

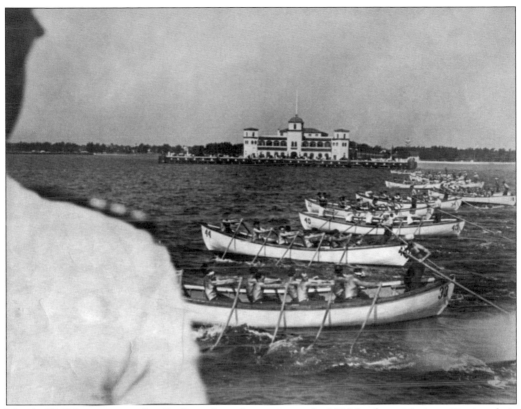

Nearly 25,000 men trained in St. Petersburg for service in the US Merchant Marines. During their training, the seamen could be seen practicing maneuvers in whaleboats off the Million Dollar Pier (above). While war boats called on St. Petersburg and could dock at the pier, an unusual group sought out the space as well. In the summer of 1945, about 100 young ladies had their hearts set on using a portion of the Municipal Pier as the headquarters for the Girl Scouts Mariner Ship group. Their male counterparts, the Sea Scouts, already occupied a pier space, with support and guidance provided by Kiwanis Club members. The pier, with its close proximity to Spa Beach, made it an "ideal site," according to adult leaders who wanted to conduct swimming, sailing, and lifesaving lessons for both boys and girls.

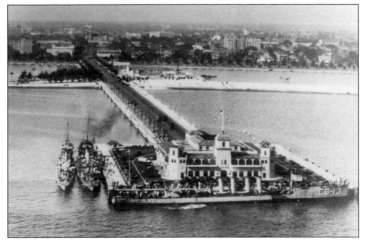

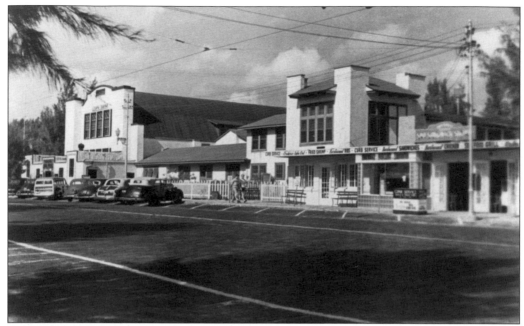

At the approach to the Municipal Pier is the Spa Beach, one of the popular gathering places of the city for swimmers and those who want to suntan. Located nearby is the Solarium, a veritable temple of the sun.

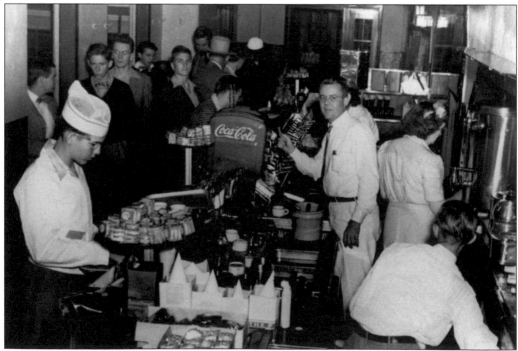

In 1945, the municipally operated grill on the pier head served a whopping 603,767 customers. The establishment specialized in fish sandwiches, homemade chips, and ice-cream floats. Manager Bill Scarborough predicted that the influx of returning World War II soldiers and their families would break that 12-month record in 1946.

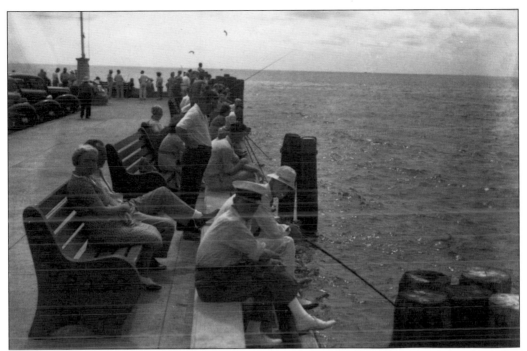

Locals who specialized in fishing for shark flocked to the Municipal Pier in the early 1950s. Choosing evening hours, as this was the ideal feasting time for the gray beasts, anglers would use 72-pound test lines and frequently haul in catches weighing as much as 500 pounds.

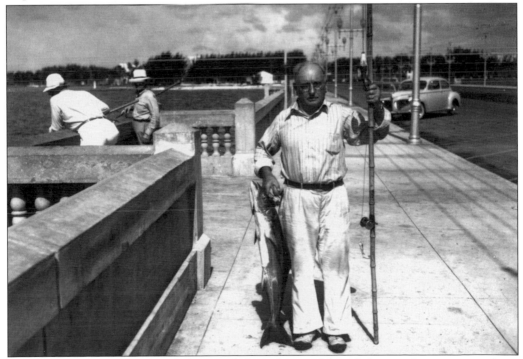

Redfish were a popular and abundant catch from the pier fishing balconies. In just two weeks in October 1946, fishermen reeled in thousands of pounds of the delectable seafood favorite.

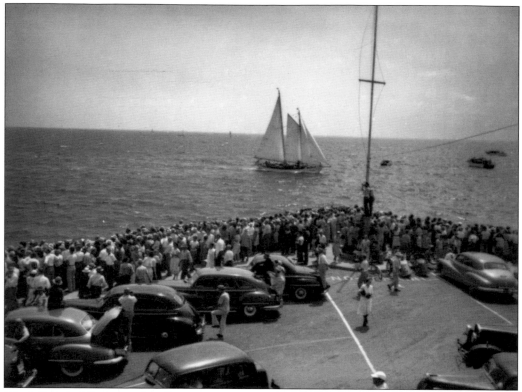

The Municipal Pier served as the primary viewing platform and one of the triangulation points in the 1949 running of the Festival of States Regatta. The event, featuring entries from as far away as Ft. Lauderdale, Miami, and Daytona Beach, was designed to pit young skippers, ages 12 to 14, against one another in a sailing course from the pier to Bayboro Harbor and back. St. Petersburg Yacht Club member Al Gandy was principal judge for the popular event.

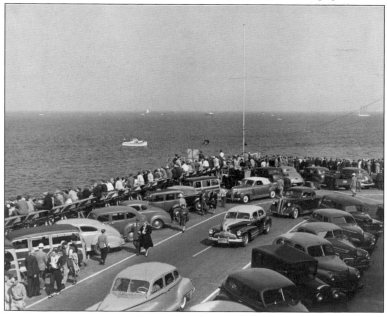

Powerboat racing in the bay was a favorite with spectators, who could get a perfect finish-line view right from the Municipal Pier. The E.L. Jones Trophy was a hotly contested prize for the bay racers. Rather than just speed, boat captains were judged on their ability to successfully navigate a course to their own specified time limits. The skipper finishing closest to his predicted elapsed time won the event.

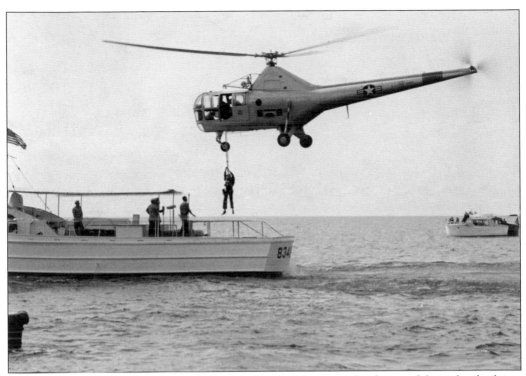

Located at the southwest corner of Albert Whitted Airport, on land created from the dredging of Bayboro Harbor, St. Petersburg's US Coast Guard Air Station was built in 1934–1935 with Public Works Administration (PWA) funds and under Works Progress Administration (WPA) guidelines. Decommissioned in 1976, the air station is now located in Clearwater, a few miles to the north. For over four decades, the St. Petersburg facility was an active part of the community and ensured the citizens' safety. Air-sea rescue demonstrations were a routine activity off the shores of St. Petersburg. Crowds by the thousands would gather on the shore and the pier to witness these lifesaving techniques.

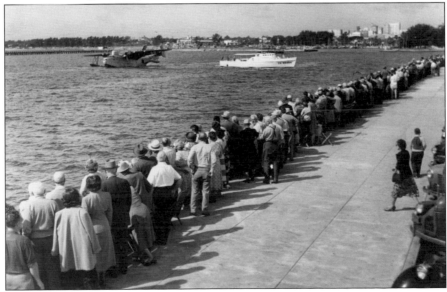

With a clear line of sight and few physical obstructions, the decision to locate radio station WSUN at the Municipal Pier head was a logical choice. However, by the mid-1950s, WSUN experienced many technical and frequency changes, including an audience loss to the growing fad of television.

In 1952, a live network broadcast by ABC radio personality Don McNeil (sitting to the left at the table in the foreground), of *Breakfast Club* fame, delighted local audiences. The chamber sold the station in 1966, about a year before its home on the Municipal Pier was demolished. One broadcast history expert claims the original WSUN transmitter was part of a permanent exhibit in the 1960s at the Smithsonian Institute in Washington, DC.

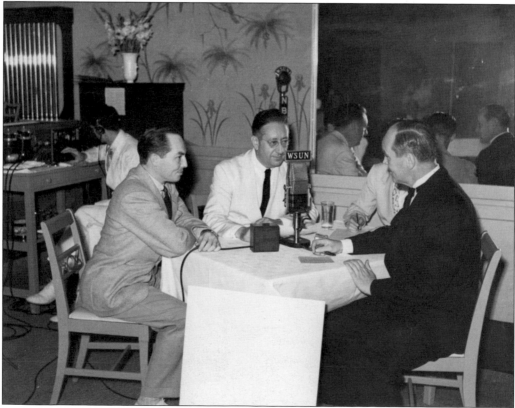

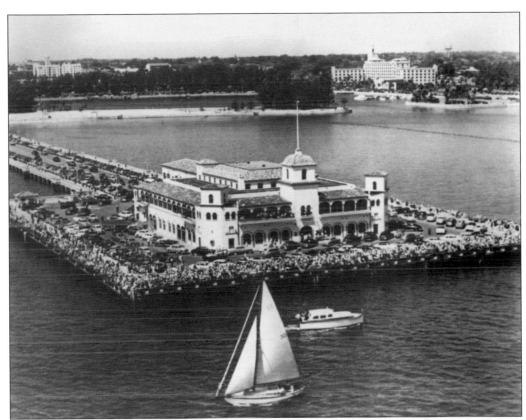

From dugout canoes and Spanish galleons to Union gunboats and Prohibition-era rumrunners, boats have long been using the waters of Tampa Bay. In the 1950s, as the waterfront and yacht basins continued to be developed, small boats and pleasure ships were a common sight from the Million Dollar Pier.

By 1950, St. Petersburg's population neared 100,000. With the increase in visitors and permanent residents, the waters of Boca Ciega Bay and Tampa Bay came to life with skiers, sailboats, and skiffs.

Following World War II, the city continued to grow, but not without the aid of promotions and publicity. Photographs of the Green Benches, like this one, circulated in thousands of newspapers, and bright vivid postcards were mailed worldwide.

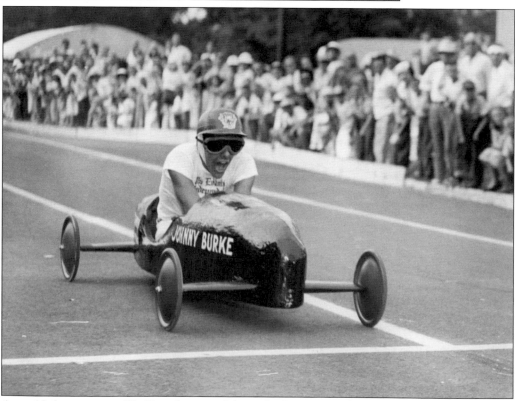

An unlikely promoter of St. Petersburg was Johnny Burke. He won the 1950 St. Petersburg Soap Box Derby, qualifying for the national championship in Akron, Ohio. Although he lost the race, the publicity of the Sunshine City and his accomplishments went nationwide. After graduating from St. Petersburg High School, Burke joined the military, serving as a Marine hospital corpsman.

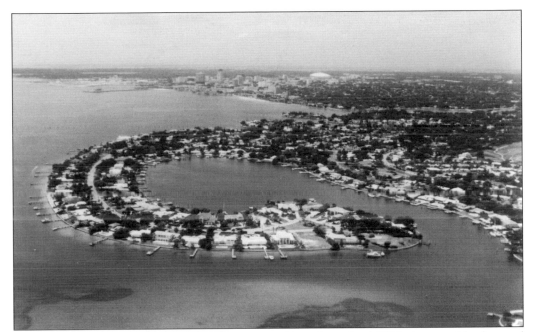

With upscale housing in demand, developers turned liquid into land. With the use of dredges and dikes, Snell Isle was developed by C. Perry Snell. The architecture is a mixture of European and Spanish styles, which complemented the elegant nature of the island. By 1950, Snell Isle Harbor was a thriving community.

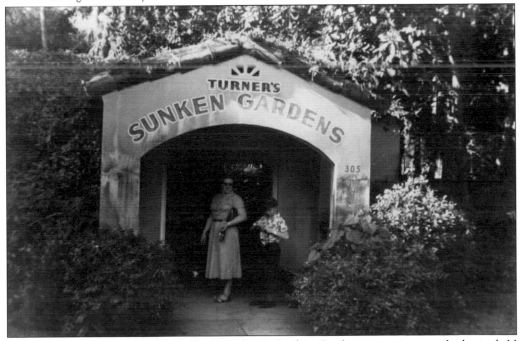

Perhaps not as elegant as Snell Isle, St. Petersburg's Sunken Gardens attraction was the brainchild of plumber and avid gardener George Turner Sr. When Turner purchased the four-acre site in 1903, he drained a shallow lake and planted hundreds of exotic plants to create his "sunken" gardens. By 1950, the gardens were among Florida's top 10 commercial attractions.

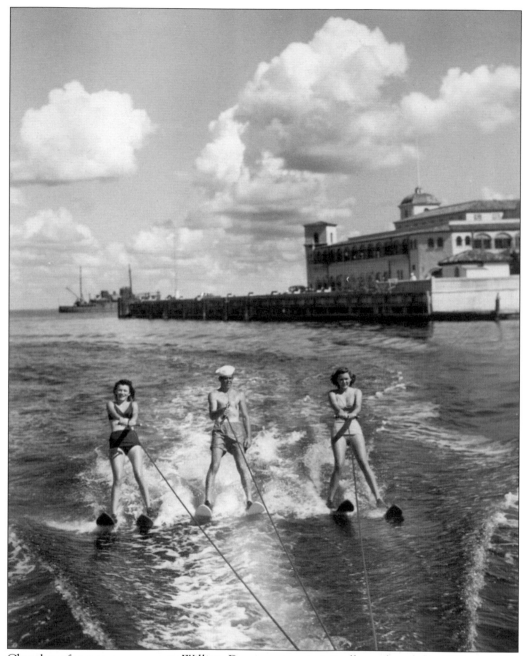

Chamber of commerce manager William Davenport optimistically predicted that 1951 would be an excellent tourist season for St. Petersburg. Indeed, the annual native orchid and tropical fish show at the Municipal Pier drew more than 1,000 spectators and gardening hobbyists. Waterskiing exhibitions in the yacht basins were often staged for the younger crowds.

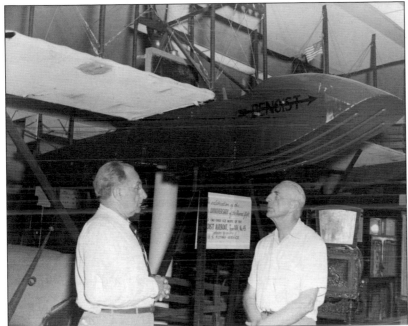

Celebrating the 50th anniversary of the 1914 birth of St. Petersburg–Tampa Airboat Line, adverting guru Pressley Phillips (right) chats with Benoist's original mechanic, J.D. Smith. The replica, housed at the Museum of History on the pier approach, flew over the bay to mark the occasion.

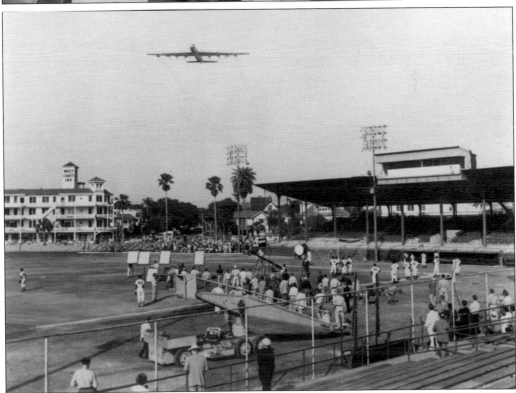

The following year, and just two blocks south of the pier, Al Lang Stadium made its Hollywood debut. The field was featured prominently as the setting for the first 10 minutes of the motion picture *Strategic Air Command* starring Jimmy Stewart. Before it ever flew a mission, the huge B-36 bomber seen here was made obsolete by missile-defense technology.

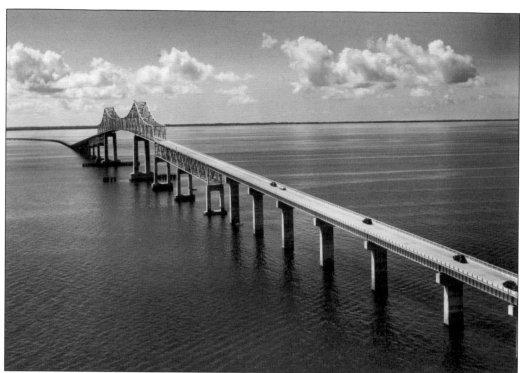

The 1950s were indeed a time of prosperity for St. Petersburg. On Labor Day 1954, Gov. Charley Johns officially opened the Sunshine Skyway Bridge to thousands of waiting automobiles and their excited passengers. By midnight, 15,000 vehicles had spanned the waters. Now a direct link from Pinellas County to Manatee County, the bridge shaved off nearly an hour of drive time and reduced the trip to a mere 10-minute sightseeing excursion. Towering nearly 15 stories above the bay, the elevated structure provides a 750-foot-wide passage for ships crossing Tampa Bay, thus eliminating the need for a drawbridge. At a cost of nearly $15 million, the bridge was not a financial burden to the community. In 1947, voters approved a construction bond issue, which mandated that all monies repaid come from tolls collected, not from taxes raised.

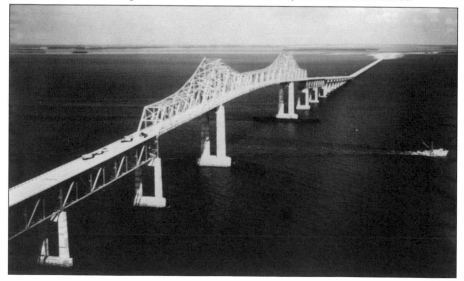

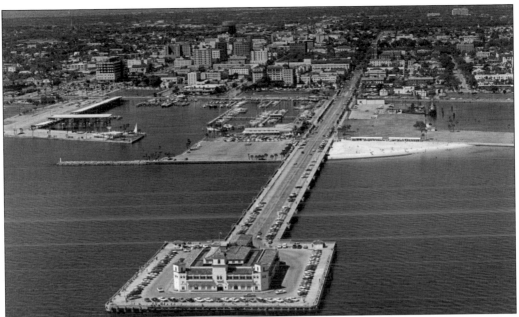

With a street-rail trolley system extending out to the pier head, the double-deck casino and 14 fishing balconies were convenient gathering spots for hundreds of locals and visitors each day. However, all this activity would create some undue damage to the bay. City engineer Paul Jorgensen led the way in 1955 to help reduce water pollution created by the Municipal Pier. Prior to his project, pier plumbing drained into a large septic tank and then was released directly into the bay. An $8,000 sewage-ejector system was finally installed to pump wastewater through a pressure main to the city's water treatment plant at the edge of Albert Whitted Airport.

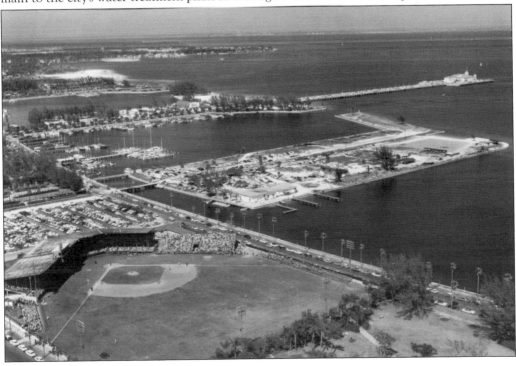

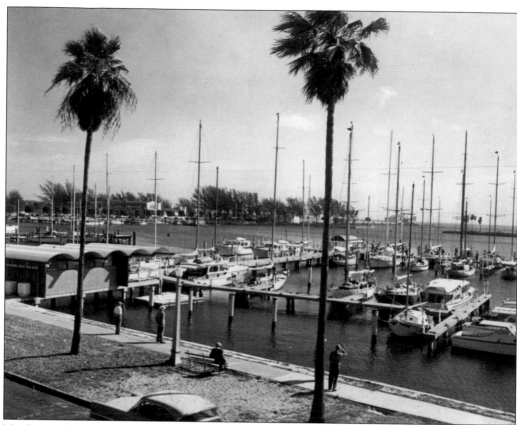

Newly installed docks adjacent to the Municipal Pier, at the Yacht Club, were a welcome sight for many boat owners and visitors. However, for those who would rather vacation on four wheels, the pier was the place to be in the summer of 1952. The National Trailercoach organization staged its 1952 dealer convention in St. Petersburg, using the Municipal Pier as a giant parking lot and "showroom with a view." After dealers from around the country received their two days of new model inspections and sales briefings, the public was invited to check out the recreational vehicles. Rube Allyn claimed he saw some trailer salesmen fishing in total comfort, catching sheepshead from the back windows of their trailers. Like all good anglers, Allyn was known to possibly exaggerate some of his tales.

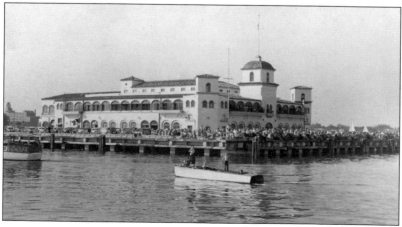

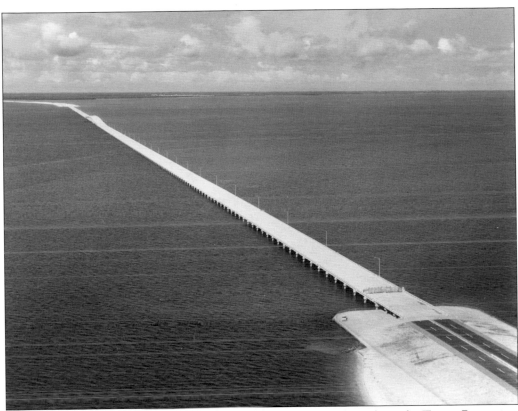

Building booms and seemingly never-ending population spurts throughout the Tampa Bay region created the need for more bridges to span the bay. George Gandy's 1924 bridge to Tampa and the 1954 Sunshine Skyway Bridge to Manatee relieved much traffic congestion, and the completion of the Howard Frankland Bridge in 1960 was a relief to many commuters.

With a growing population came the need for more services and educational opportunities. While Albert Whitted Airport continued serving an ever-growing aviation community, the adjacent track of land was selected to be the future site for the University of South Florida's St. Petersburg campus in the early 1960s.

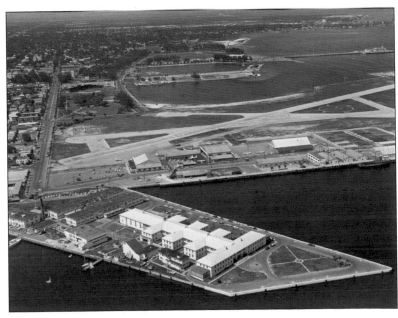

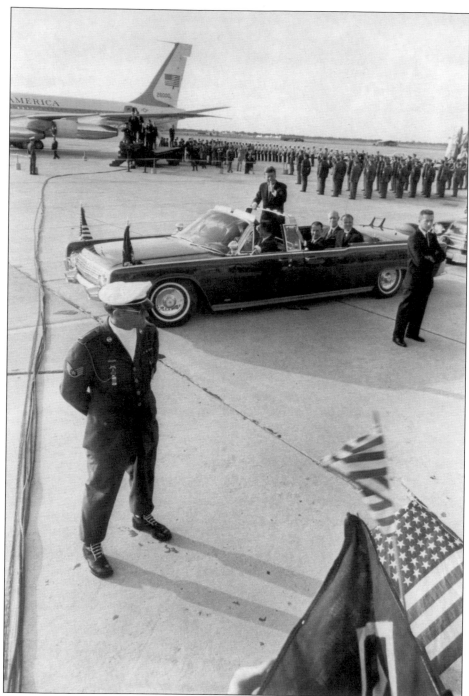

Just four days prior to that tragic day in Dallas, Texas, Pres. John F. Kennedy visited the area. Kennedy had a passion for politics and aviation history, and his political junket at MacDill Air Force Base in Tampa also celebrated the 50th anniversary of the birth of the world's first scheduled commercial airliner. Little did aviator Tony Jannus know that, five decades after he piloted that first flight across Tampa Bay on January 1, 1914, he would be honored by the nation's 35th president.

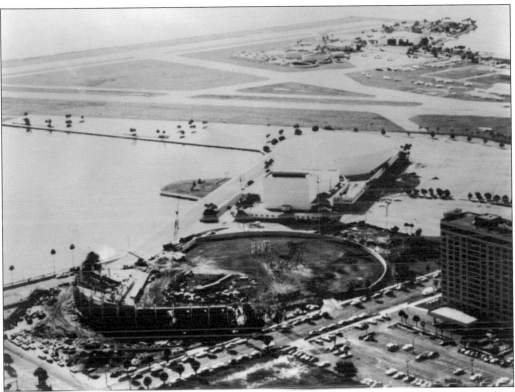

Construction began on the waterfront's newest venue, the Bayfront Center, in 1963. The indoor arena would hold crowds of up to 7,500 and host myriad events. Hockey, soccer, basketball, wrestling, and boxing were just some of the many sporting events held here.

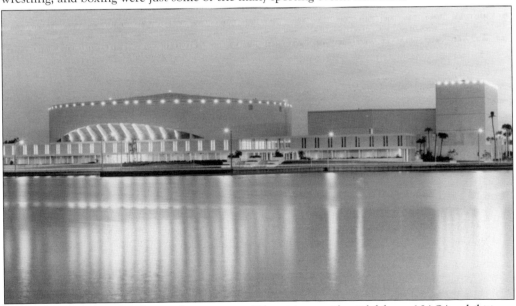

During its nearly four-decade run, the venue would host vice-presidential debates, NASA exhibitions, and concerts. The spot proved a popular venue for Ringling Bros. and Barnum & Bailey's yearly television specials.

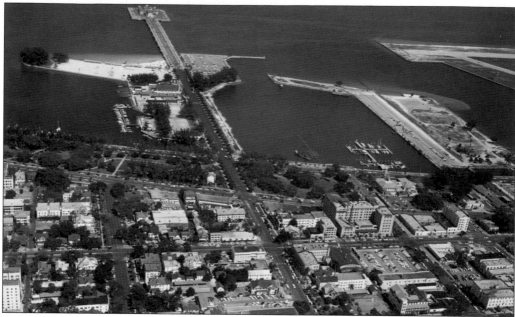

As the Million Dollar Pier fell into disrepair in the mid-1960s, one investor group proposed turning the bay feature into a pirate's den tourist attraction. The Jacksonville group envisioned a shopping center along the pier approach, interspersed with rides, amusements, and souvenir attractions. A competing group wanted to build a series of lower-level fishing decks around the pier head perimeter. And another citizens group proposed a Williamsburg, Virginia–style village with an antique automobile museum. The city council rejected all of the suggestions, but the writing was on the wall. There were growing concerns over the longevity of the city's beloved Million Dollar Pier.

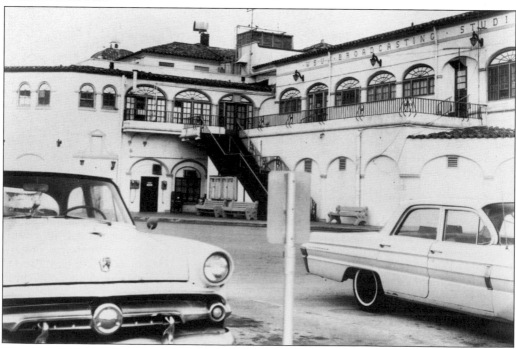

While staged photographs on the piers and the waterfront had been commonplace for decades, St. Petersburg's reputation as an arts and cultural center did not just happen overnight. During the summer of 1965, the parks and recreation department conducted arts and crafts classes at the Municipal Pier. For a fee of $3, adults could take eight weeks of classes in oil painting, cartoon drawing, copper tooling, mosaics, and creative ceramics. Similar sessions had previously been held at the city's community center and other venues.

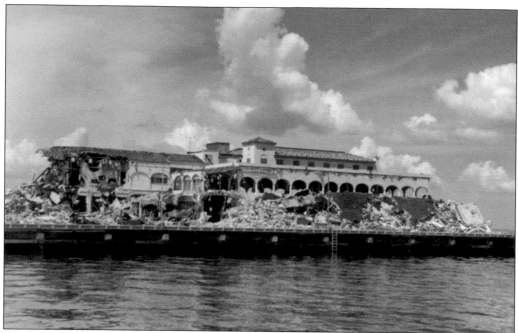

After millions of visitors and more than 40 years as the city's waterfront landmark, the Million Dollar Pier was destined to come down. The Cuyahoga Wrecking Company began stripping the structure in July 1967. All salvageable material was sold off at a fraction of the original cost. Huge windows fetched $10 per three-pane section, gorgeous wooden banisters could be had for 20¢ a foot, and the ornate wrought-iron railings prevalent in the structure pulled in $1 per foot. Ceiling fixtures, lights, and doors by the dozens were swooped up. But the "real prize," noted the *Evening Independent*, were hundreds of feet of pine boards used throughout the Mediterranean-style structure. While an end of an era had come, hundreds of folks brought home a piece of history.

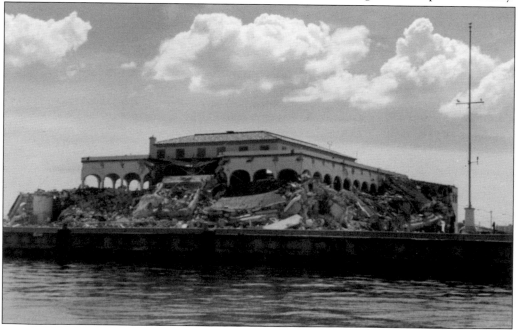

Five

TIMES OF CHANGE
1967–2013

Following the demolition of the Million Dollar Pier in 1967, the pier head was converted into Pier Park. Devoid of the Mediterranean-themed structure, the park was a paved expanse of picnic shelters, benches, and tables, with a few scattered cement planters of palm trees. Gone was the majestic building that once graced Tampa Bay.

The city council approved a new pier structure, to be completed in time for the 1970–1971 tourist season, with costs not exceeding $2 million. Seeking a radical, forward-looking design, the council selected the inverted pyramid design of architect William Harvard Sr. Now known as simply The Pier, the delayed building finally opened in January 1973, coming in at $2 million over budget.

The Pier offered three restaurants, snack bars, novelty shops, and breathtaking views of Tampa Bay, but operational costs were skyrocketing. Lawsuits, leaky roofs, and saltwater erosion resulted in a decline of tourists and several management changes. By 1986, it was just too much. The Pier temporarily closed for $12 million in renovations.

It seemed the worst was over when The Pier reopened on August 22, 1988, featuring an expanded first floor with more shops, a boat dock, glass elevator, and an aquarium. However, within a year, there was more bad news with the discovery of structural decay and leaks to the pier approach. An annual operations deficit of $1.2 million was forecast due to malfunctioning elevators, chronic air-conditioning and heating issues, and trolley breakdowns.

By 2004, further reports reveal that the approach and pier head, built in the 1920s, were deteriorating and had to be replaced within 10 years at a cost of $25 million to $40 million. This spurred much debate about whether to repair or replace. Even though an initial $50 million was approved for repairs, the city moved forward in 2009 with plans to demolish the inverted pyramid.

Lawsuits, petitions, and referendums clouded the future of the Sunshine City's 40-year-old structure. Nevertheless, The Pier was closed on May 31, 2013. As of this writing, nearly two years later, it sits there as a locked, decaying reminder of what was and what could be.

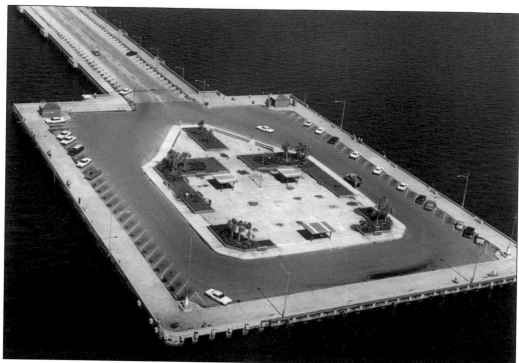

The top three choices in 1967 to replace the Million Dollar Pier were a fishing pier, a large open-air restaurant, and sidewalk cafés, according to a city survey. The *St. Petersburg Times* noted that 268 readers responding to the newspaper's nonscientific survey wanted development of lower-level fishing piers, 109 wanted a mini-park, and 20 readers thought a Disney-like theme park would be a good use for the 40-year-old pier. Reporter Perry Fulkerson wrote that 125 people thought a ski-lift approach to the pier head would reduce traffic volume and be an unusual attraction.

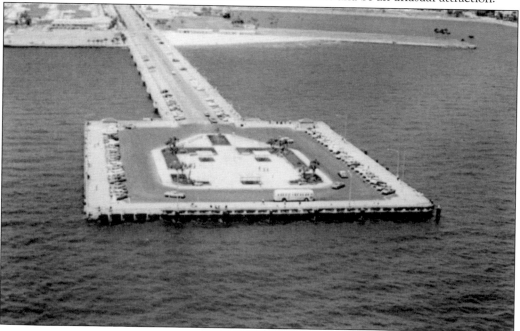

Although the Million Dollar Pier structure was gone, there was still plenty to see on the pier approach. Anglers by the troves continued casting their lines into the bay, the St. Petersburg Museum of History (pictured) entertained and educated guests about the Sunshine City's vibrant history, and the HMS *Bounty* began calling the pier its home port.

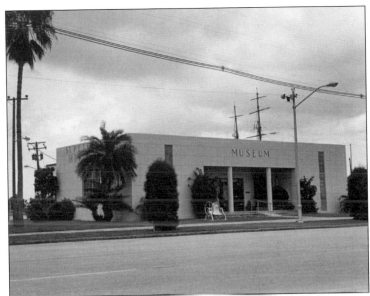

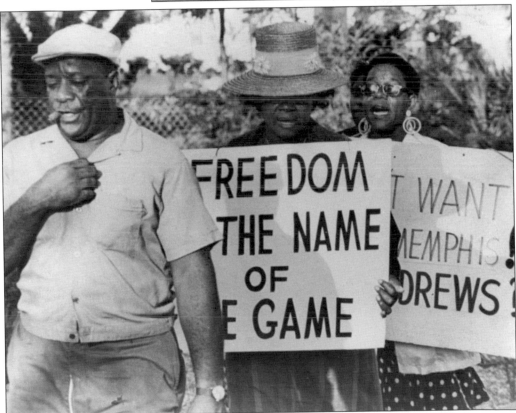

But all was not historical artifacts and tall ships in St. Petersburg. The mid-1968 sanitation strikes shined national attention on the Sunshine City. For 116 days, over 200 African American sanitation workers marched the streets and in front of city hall, demanding better pay and working conditions. Following their victory, *Times* reporter Jon Wilson wrote, "It began a new way of thinking to what had been a strictly segregated community."

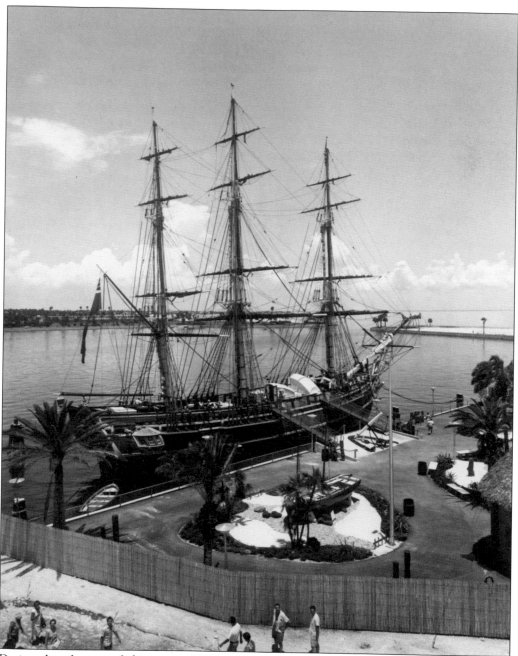

Designed in the same fashion as its 1787 predecessor, the *Bounty* was built for MGM's filming of *Mutiny on the Bounty*. Although nearly identical in appearance, the replica was actually constructed about a third larger than the original tall-masted ship to accommodate the filming crews, actors, and camera rigs. The 1962 film, featuring Marlon Brando, was a box-office hit. The iconic vessel went on to play a role as a major tourist attraction in St. Petersburg until the mid-1980s.

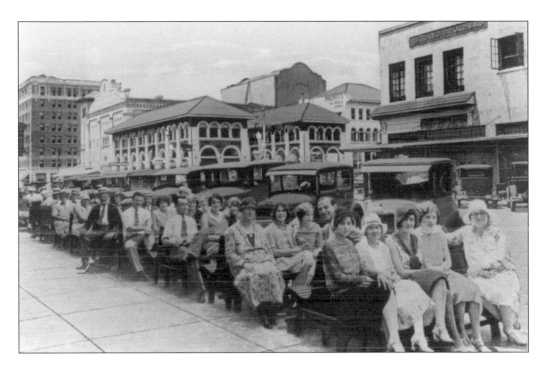

St. Petersburg's famous Green Benches once provided downtown seating for thousands of people. Beachfront property super-salesman Noel "Sand Man" Mitchell placed the first benches in front of his office at the corner of Fourth and Central Avenues in 1908. At the height of their popularity, nearly 2,400 benches lined downtown streets. The segregated seating succeeded in attracting tourists, but it also fueled the idea that St. Petersburg was what one comic called "God's waiting room." By the mid-1960s, most of the open-air seating was gone, as planners looked for ways to change the city's geriatric image. The once-famous benches "suddenly disappeared," observed the *St. Petersburg Times*, "a none too subtle hint to the city's senior citizens that their welcome was not so durable after all." What once was a city icon was little more than piled-up rubble (below).

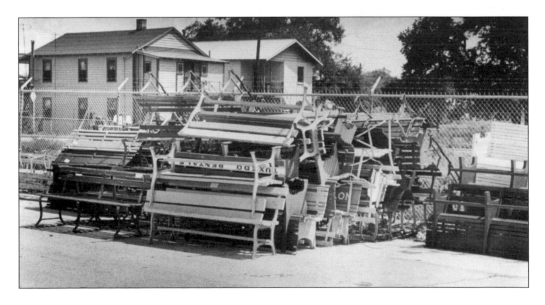

From pelicans to politicians, much was happening on the city's waterfront in the early 1970s. In the below photograph, with the Edgewater Beach motel in the background, a man has a found an unlikely friend and fishing partner. Nearby Bayfront Center hosted Pres. Richard Nixon (above). Nixon, who had previously visited in 1970, opened the rally with these remarks: "It has been mentioned, and I take notice of this fact, that I can proudly say today that I am the first President ever to visit this city of St. Petersburg. After a reception like this, I can assure you I will not be the last President to visit St. Petersburg."

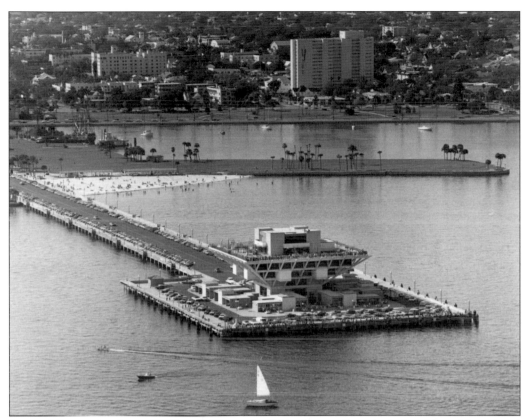

Inverted Pyramid architect William B. Harvard said his plan was "very logical, stable and functional and presented a prominent landmark." The city council earmarked $1.2 million for construction and proposed using additional funds from the sale of Bayfront Plaza. The original plan had a budget of $2 million, but later stories alternated on the cost, calling it a $4 million or 5 million pier.

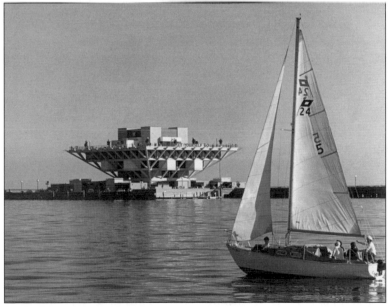

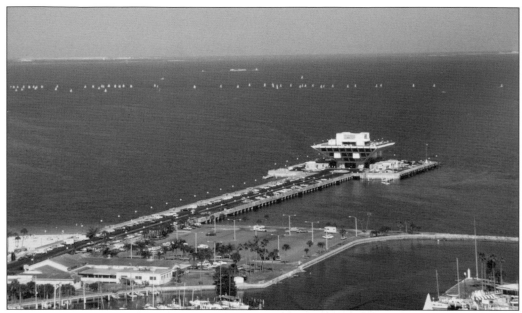

William Harvard Sr.'s design was unique for the Sunshine City, but not in the architectural world. San Francisco had opened the Inverted Pyramid Library in 1970, and the Slovak Radio Building began construction of its upside-down pyramid structure in 1967. However, his structure was unique, due to its location over the waters of Tampa Bay. It was certainly a sight to see for new visitors. Beginning in 1976, there was another sight to marvel, in the sky. Artist Rockne Krebs's laser light sculpture (below) emitted dancing rays of light from The Pier, which created amusement for some and even led others to experience supposed extraterrestrial sightings. Plagued with problems, the laser device was eventually eliminated.

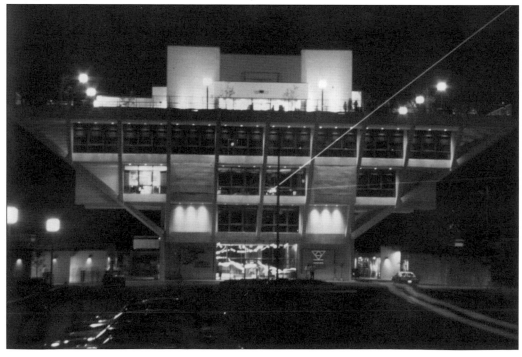

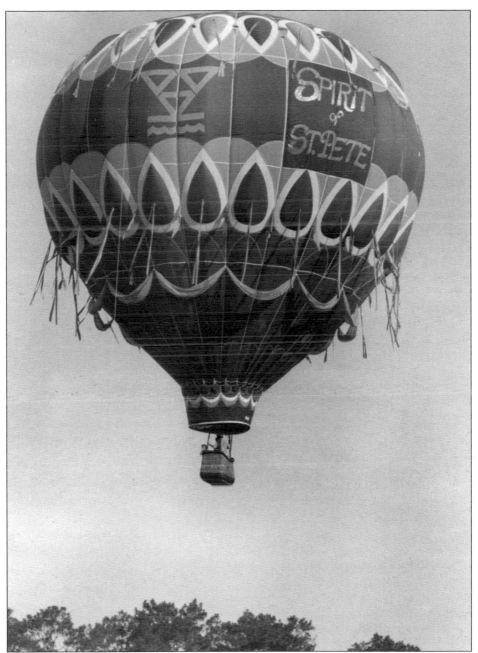

The *Spirit of St. Pete* hot air balloon was one of the attractions at Pier Place in the late 1970s, after the Million Dollar Pier and Casino had been leveled by the wrecking ball. Crowds gathered on the pier to watch pilot Antony Von Elbe guide the 55-foot-wide balloon during festivals and competitions over the bay. Von Elbe, manager of Pier Place, piloted the hot air balloon in several competitions, even winning the Le Mans Moped race, which required pilots to navigate from one point to another, jump a safe distance from the balloon, and hop aboard and ride a moped to the starting point. Emblazoned with "Spirit of St. Pete" in four-foot-high letters, the brightly festooned balloon and intrepid pilot would even compete in an endurance race from Bimini to Ft. Lauderdale, Florida.

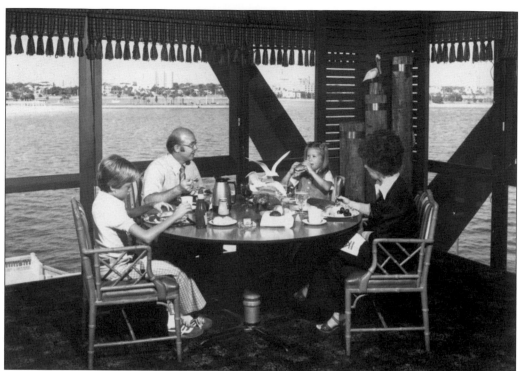

At a cost of $4 million, well over the estimated proposal of $2 million, and five years after the demolition of the Million Dollar Pier, The Pier made its debut on January 20, 1973. The city council initially gave a five-year management contract to Marriott Corporation. Marriott had lost $147,000 in the first year of its contract with the city. It then asked for and received a city-backed bailout that cost taxpayers another $69,000. Marriott blamed the energy crisis and red tide for low tourist turnout. Marriott let the agreement expire, resulting in Miami-based Hardwicke Management Companies, Inc., operating the facility. By 1979, amid allegations of mismanagement and the poor performance of retail shops and restaurants, Hardwicke proposed an upscale restaurant to "save" The Pier. From the Harborside restaurant (above) to the Perfect Touch clothiers (below), The Pier would see dozens of shops rotate in and out in its four decades.

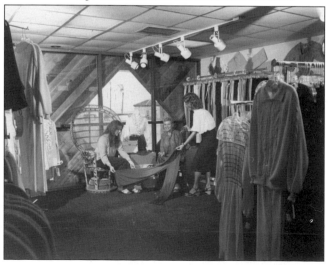

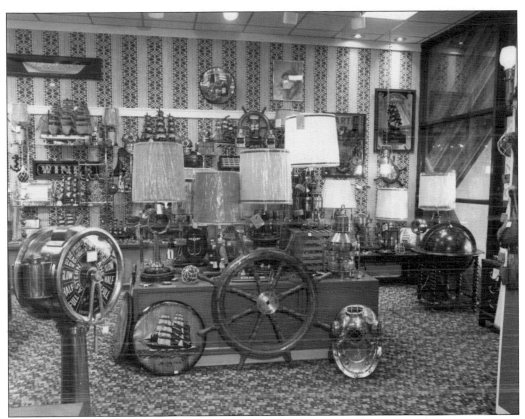

On opening day, the Inverted Pyramid had a total of 13 shops, including a glass-blowing exhibition. Selling everything from seafaring wares to Florida-themed trinkets, toys, and t-shirts, a variety of novelty shops invited tourists to spend time and money at the city's newest attraction. The over-the-top Brassaloon cocktail lounge (below) was saturated in Victorian furnishings. It featured a large gazebo bandstand, potted plants, and a menu of specialty items. With live entertainment every night until midnight or later, diners swooned under velvet valances while taking advantage of the $2.95 dinner specials. Early birds could grab lunch for a mere $1.65.

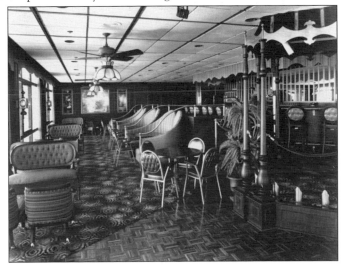

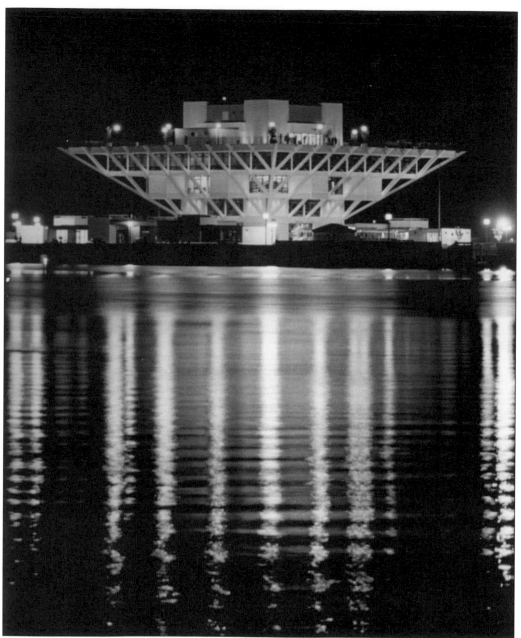

The Pier's architect, William Harvard Sr., had become quite a figure in the architecture world, especially in the Sunshine City. Harvard served as chairman of the City of St. Petersburg Zoning Board, built numerous landmark structures, and also designed residential housing, to much fanfare. Promoters were quick to jump on the popularity of the pyramid and its modern design. One newspaper advertisement for a local builder promoted the fact that this "sprawling 2 bedroom home was artistically designed by architect William Harvard" and was "modern as tomorrow." Another advertisement claimed its $14,500 air-conditioned home was "solid as a pyramid." From Tampa's St. Joseph's Hospital and St. Petersburg's St. Anthony's Hospital, to churches, park pavilions, and even Busch Gardens' Hospitality House, William Harvard's designs have won numerous awards and accolades. Many of these structures survive to this day.

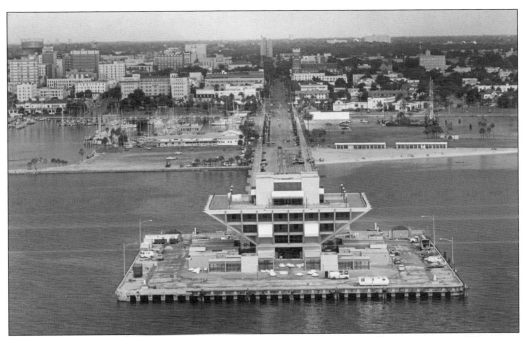

Al Willingham of Harvard Jolly Architects said the foundation for the new Inverted Pyramid consisted of four concrete-and-steel pilings that reached a height of 70 feet. These were set into several feet of limestone on the seafloor of Tampa Bay. Engineers claimed the bay's floor rock would support a load of 200 tons at each of the four major pilings. Each piling was made of 21 steel beams and approximately 1,000 cubic yards of continuously poured concrete. The use of triangle support frames not only lend the building its unique shape, but they also support tremendous weight.

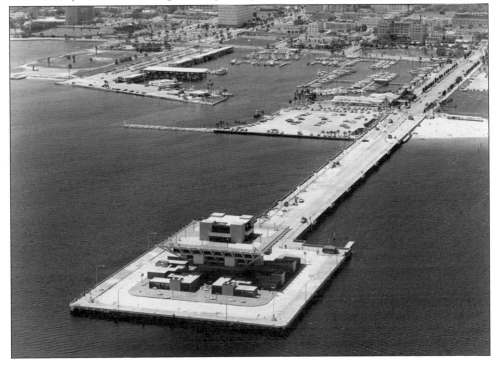

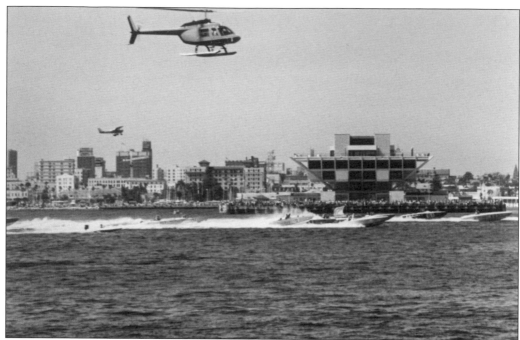

Sailboats and skiffs have long been a common sight off the shores of St. Petersburg's waterfront. In 1930, George S. Gandy Jr. (son of local bridge builder "Dad" Gandy) and Commodore Rafael Pooso of Havana, Cuba, organized the first St. Petersburg–Havana yacht races. The shores came to life with festivals, parties, and cheering crowds. For 30 years, the St. Petersburg Yacht Club sponsored the races. Fidel Castro's overthrow of Cuba put a halt to the annual 284-mile contest. However, other events, such as the Hurricane Classic boat race, soon followed. These 1975 photographs show competing boats racing past the iconic pier.

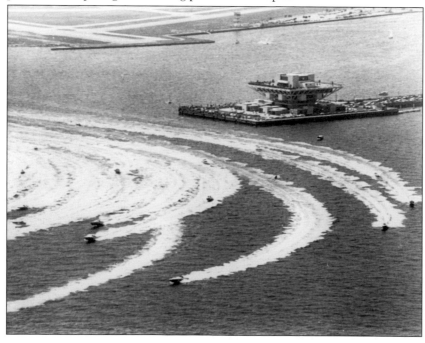

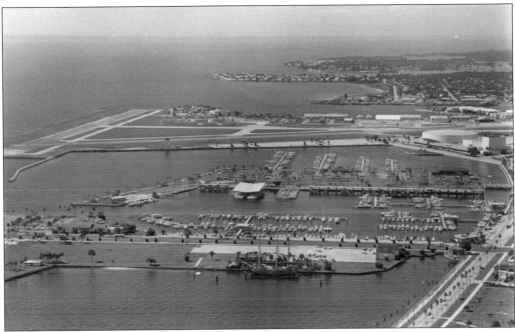

Hardwicke took over operations in 1978 after Marriott had allowed its four-year unprofitable contract to expire. Hardwicke renamed the area "St. Petersburg's Pier Place" and lost $14,000 of city money during its first two months of operation. But, in the third month, the company claimed a first-time city profit of slightly more than $7,000. The management deal called for the city "to absorb all loses incurred" and to pay Hardwicke $75,000 a year plus a percentage of the profits over $1.5 million. The contract between Marriott and the city had been quite different, requiring the hotel-chain operators to lease the pier building from the city. It was also obligated to pay the city a percentage of gross sales, whether the pier was operating in the red or not.

The Pier continued to lose money on a regular monthly basis, and city fathers learned another expensive aspect of Murphy's Law: there are certain enterprises a city should leave up to the private sector. In 1977, the city council voted to buy the Edgewater Motel, operate it for a seven-year duration to pay off the property, raze it, and develop a city park. The only problem was that the motel (seen here above Kids and Kubs baseball field) stopped being profitable. The first three months of city operation took in about $18,000, compared to nearly $80,000 the previous three months.

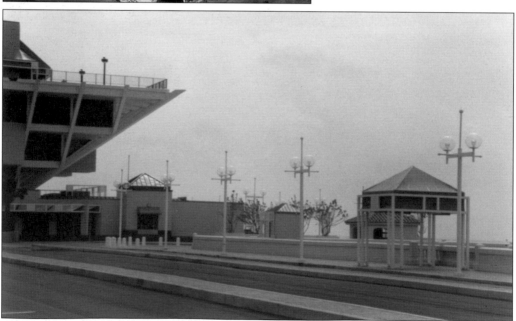

On The Pier, the centerpiece attraction, Pier Place—also city owned and operated—was losing money at about the same rate. Trying to sound positive, city finance manager Matthew Bufwack said the annual loss projected for 1978 probably would not exceed $200,000—and that was the good news. He told reporters in August that free hors d'oeuvres and two-for-one happy hour drinks would hopefully reverse the losing trend. It did not.

In 1979, motorcycle stunt rider Don Brock of Largo wanted to use The Pier approach in an attempt to break Evel Knievel's record jump of 23 trucks. The city council nixed his Festival of States finale idea. Undeterred, the Christian athlete said, "The Lord didn't want me to make that jump." Brock went on to perform daredevil jumps (twice breaking Knievel's records) by working with area Baptist churches in what he called "Jumping for Jesus." Brock found the technique an especially effective way to reach young people. He also claimed his unorthodox ministry jumps were "safer than driving on US 19."

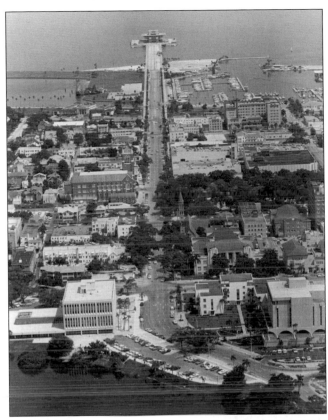

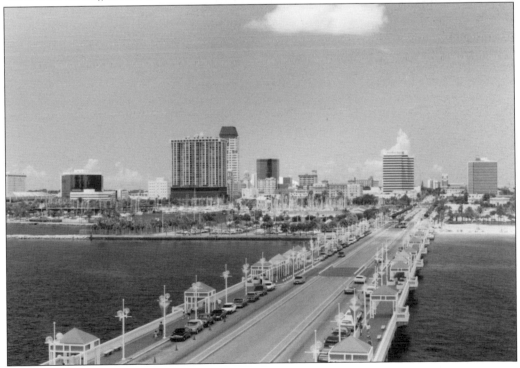

What began as a 17-by-28-foot storefront on the "wrong side of the tracks" in 1925 rapidly ballooned into a monolithic empire occupying nearly 10 city blocks, thanks to the vision on James Webb. "I don't give a damn about money, I want customers," he once declared in an interview. And did he ever get them—up to 60,000 daily. The 1950s and 1960s were the golden decades for the "World's Most Unusual Drug Store." In 1970, Webb's City consisted of more than 70 individual stores in seven buildings with a total of 3,000 parking spaces. Sensing a downturn in the economy, and with the arrival of urban shopping malls, Webb sold his 56-percent share of the company to Texas interests in 1974. Perhaps the loss of its greatest promoter was too much for Webb's City. It went into bankruptcy and closed a few years later. Webb remained in St. Petersburg with his third wife, Dorothy, and passed away in 1982, the same year his landmark structure was demolished.

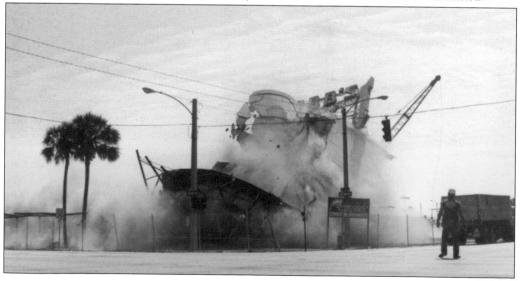

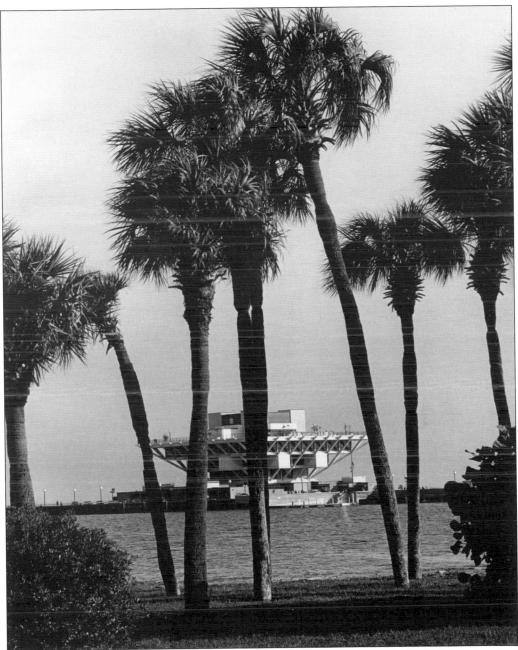

By 1986, on its 13th birthday, the city council agreed that the Inverted Pyramid structure had fallen into worsening stages of decay. Estimates by the city claimed the structure drew between 800,000 to 900,000 visitors annually, or about one third the total number of people visiting Pinellas County. But, the unprofitable Pier required city subsidies to stay afloat. With an estimate of $500,000 to repair saltwater erosion and $200,000 more to fix the leaky roof, it seemed that The Pier had become the city's albatross. Calling it "a big chunk of concrete that protrudes a half-mile into the bay," one newspaper story said, "It is remarkable the place has been a financial disaster over the years; a spot where countless marketing experiments and publicity stunts have failed to stir good feelings among the citizenry that owns it."

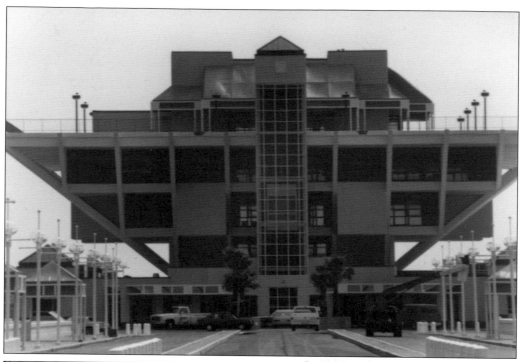

In 1986, architecture firm Sasaki and Associates, a world leader in landscape architecture, redesigned The Pier and its approach, adding more landscaping, street parking, and pavilions. "The city needs to put its best foot forward," designer George Botner told the city council, "and this is your best foot."

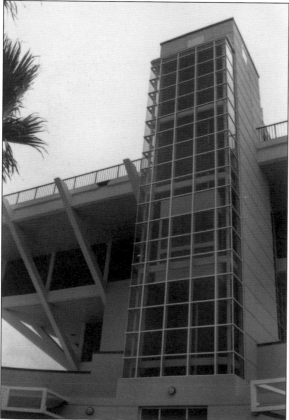

Other upgrades included an expanded first floor with more retail shops, a boat dock on the south side, and an eye-catching glass elevator welcoming guests. A tasty first-floor addition was the Alessi Bakery. The Pier Aquarium occupied the second floor. Cesar Gonzmart opened a banquet hall on the third floor and his family's famous Columbia restaurant on the fourth.

Following The Pier's 19-month, $12 million renovation, the president of Bay Plaza Companies boasted to the city council in 1988 that tenants had been found for every available square foot of the facility. New bold colors of yellow, blue, and red were splashed around the revamped geometric structure. The new concierge desk featured domed ceilings and aquatic murals. The contracts with tenants "are substantially complete," Neil Elsey said, "We're in agreement. We're working on space plans and finalizing leases." Elsey and city officials planned to hire Bay Plaza as manager of The Pier, the Bayfront Center, and the newly completed Florida Suncoast Dome.

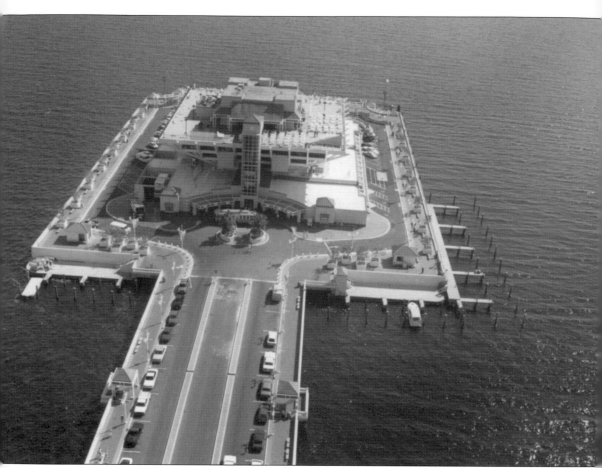

The newly renovated Pier was an immediate success. While city officials hoped that one to two million people would visit the revamped structure in its first year, they were overwhelmed when over 500,000 guests visited in the first month alone. Visitors now could hop on the trolley that ran up the center of the approach or walk the distance and grab a hot dog from street vendors along the way. The well-heeled had several boat slips to choose from on the outer edge of the pier head, anglers were provided with additional seating and shade, and the pelicans found the bait house to be superb. Once inside, Pier guests could stroll through the variety of gift shops, dine in the elegant Columbia restaurant, buy fresh catches from the fishmonger, or sip umbrella-topped drinks at the top floor's Cha Cha Coconuts. Once again, The Pier was the place to go.

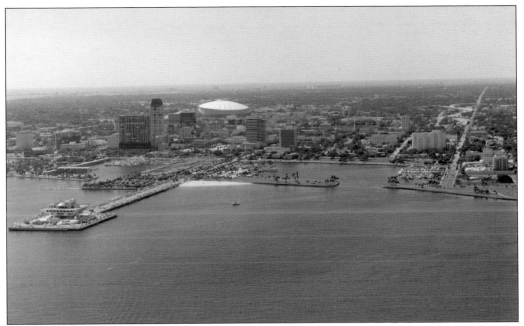

After nearly four years of construction and a $138 million price tag, the Florida Suncoast Dome was yet another major change happening in the Sunshine City. Originally designed for a Major League Baseball franchise, which would take a few more years to realize, the dome played host to many events prior to the arrival of the Rays. From hockey to jockeys, events spanned the gamut at the dome.

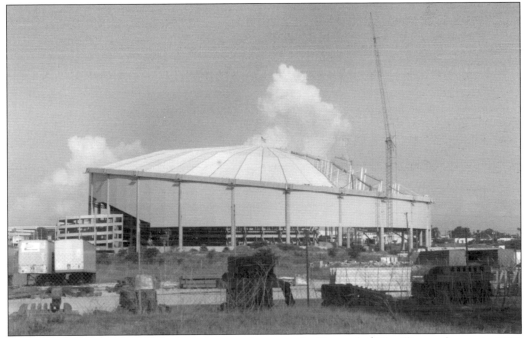

The facility would eventually undergo a name change and a 17-month, $85 million makeover in 1996 to welcome the area's first Major League Baseball team. Whether viewed from an airplane or from atop one of downtown's buildings, Tropicana Field is a notable landmark in the city's skyline.

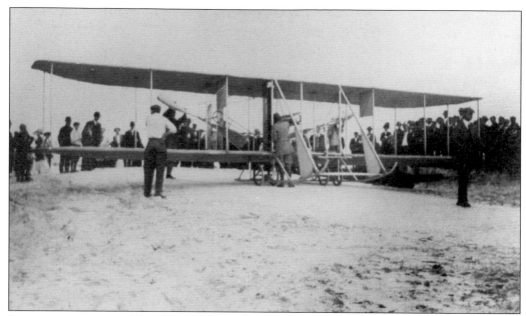

Just two years prior to Tony Jannus's arrival in St. Petersburg to fly the world's first airliner in 1914, pilot Leonard Bonney brought his 80-horsepower Curtiss biplane by train to the Sunshine City. Sponsored by local realtor Noel Mitchell, the air show featured only one pilot, Bonney, and was witnessed by 5,000 of the city's 8,000 residents. But few paid to view the show, instead cramming the railroad pier for a free waterfront daredevil show. Bonney lost money on the show, never to return to St. Pete.

Years later, in 1989, The Pier and waterfront provided an excellent vantage point for spectators to watch a demonstration of the US Marine Corps' Harrier, the vertical-take-off airplane, at Albert Whitted Airport during the Festival of States "Warbirds Air Show" celebration. "Air Control Tower operators made as much noise as the spectators when the plane got perilously close to the tower," said event organizer and current Museum of History director Rui Farias, "until they realized Congressman C.W 'Bill' Young was aboard."

Although perhaps most widely known for The Pier, William Harvard also designed other local structures, including the Federal Building in St. Petersburg, the Tides Hotel at Redington Beach, Pasadena Community Church (pictured), Derby Lane, St. Petersburg Federal Savings and Loan building and addition, the St. Pete Beach Municipal Building, and the St. Petersburg Public Library on Ninth Avenue North.

William Harvard's legacy may possibly not be his iconic Inverted Pyramid, but the one-story, 44,700-square-foot main public library that has provided books for millions of readers since it was opened in 1963. Or, perhaps, he will be remembered most for the Williams Park bandstand (pictured with the First United Methodist Church in the background), which he designed as a young man. Harvard died in 1995 at the age of 84.

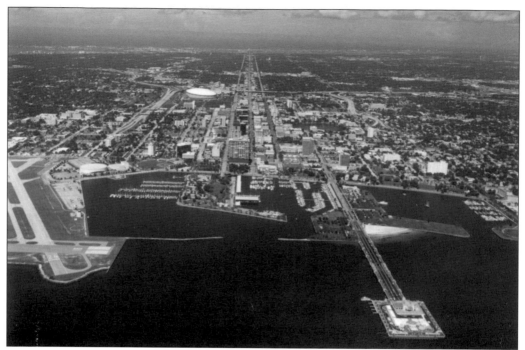

This aerial photograph of the waterfront captures the growth of St. Petersburg's downtown by the late 1990s. By the turn of the 21st century, however, there would be a major downtown revival and an impressive growth spurt in luxury high-rises on and around the city's swanky Beach Drive.

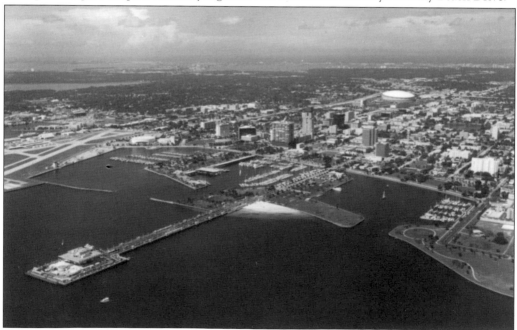

The large swaths of parklands pay tribute to the city's nearly 100-year commitment to preserving waterfront parks, thanks to early landowners and preservationists William L. Straub and C. Perry Snell. In fact, some historians claim that St. Petersburg, behind Chicago and Vancouver, boasts the third-largest downtown waterfront park system in North America.

Installed amid controversy in September 2000, the Museum of History's Newspaper Boy statue waves a replica copy of the September 1910 edition of the *Evening Independent's* "Sunshine Offer." The offer provided to any denizen, free of charge, that evenings' newspaper should the sun fail to have shined on the city by press time.

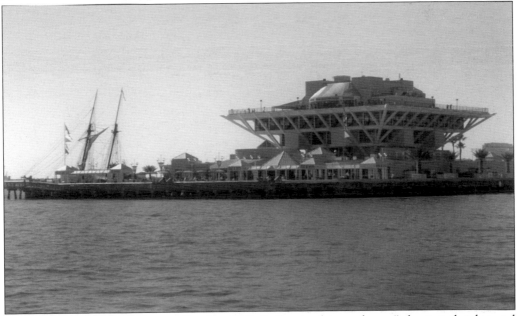

At the other end of The Pier, in October 2002, "a floating history lesson" about civil rights and slavery docked at the facility. The 85-foot replica of the slave ship *La Amistad* was designed to be a catalyst for racial harmony, especially among youngsters, noted author and historian Jon Wilson.

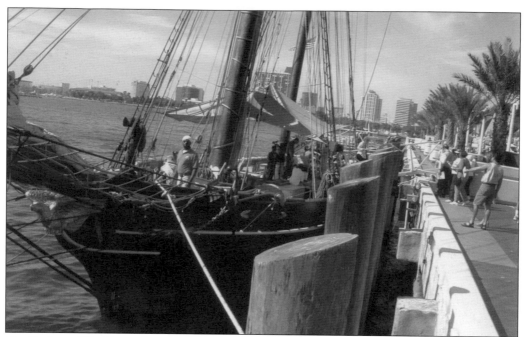

On display at The Pier in late 2002, the *La Amistad* replica serves as a human-rights symbol and speaks to the victorious actions of the 53 kidnapped Africans who overthrew their captors in 1839. They were apprehended by the US Navy and brought to trial for piracy and murder. John Quincy Adams defended the Africans before the Supreme Court, resulting in an acquittal and return to their native home of Sierra Leone.

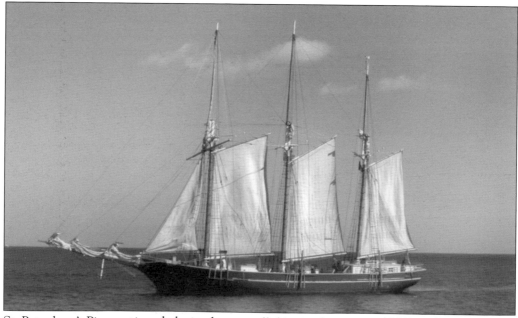

St. Petersburg's Pier continued playing host to tall ships in the winter of 2002 with the arrival of the sailing vessel *Denis Sullivan*. The world's only replica of a 19th-century Great Lakes schooner, the SV *Denis Sullivan* acts as a 138-foot floating classroom for environmental stewardship and freshwater education.

The early 2000s was certainly a time of visiting tall ships and historic vessels. However, two new, almost futuristic sights could now be seen off The Pier. Although not wildly successful, the hovercraft and Tampa Bay Duck tours delighted many onlookers. The 37-foot amphibious vehicle was docked just off The Pier's Pelican parking lot and could transport up to 12 guests to Pinellas Point or Egmont Key.

Just as eye-catching as the hovercraft were the "Ducks," which billed themselves as "half truck, half boat, all fun." Basically a modified World War II military amphibious transport, the GMC-produced vehicle could reach speeds of 50 miles per hour on land and nearly six knots in the waters of Tampa Bay. Although both were short-lived Pier attractions, the hovercraft and Ducks provide fond memories for many.

In 2005, as the city experienced a building growth of storefronts and condominiums on the waterfront, The Pier management was desperate to try anything to boost visitor traffic. They planned a promotion loosely based on the hit CBS television show *Survivor*. The Pier's version, called "Summer Survivor," was based on this premise: the castaways are Floridians, adrift in an endless, sweltering summer. The challenge is to find clues amid The Pier's shops, restaurants, and activities. Instead of $1 million, the prize will be a treasure chest of loot from Pier tenants and area businesses. The contest was aimed mainly at locals, but everyone was encouraged to participate, according to Susan Robertson, marketing manager for The Pier.

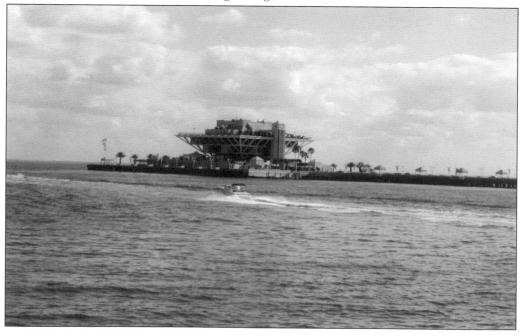

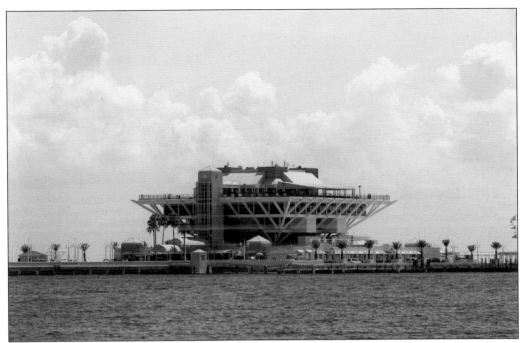

With declining visitors and skyrocketing repair subsidy costs, city officials announced plans for a $50 million restoration of The Pier in 2006. However, in August 2010, the city council voted to demolish the structure, and within a year, council members approved three finalists in an international design competition for a new facility. The three designs were unveiled, the models went on display at the Museum of History, and a favorite was chosen.

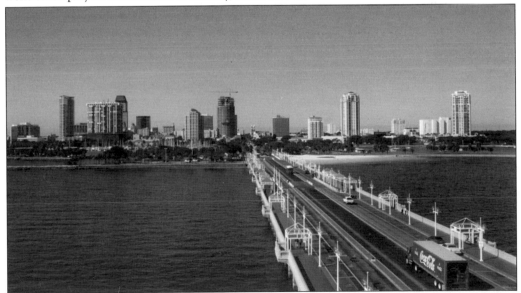

Following Mayor Bill Foster's February 2012 announcement that "The Pier will close next year," a citizens' initiative petition to save the Inverted Pyramid gained momentum. True to his word, Mayor Foster went forward with closing The Pier on May 31, 2013. Although the city council declined to put the "Save the Pier" issue on the upcoming ballot, a referendum came to a vote and halted plans to build the chosen replacement, called the Lens.

At the close of 2014, the Inverted Pyramid sat at the end of the pier approach, padlocked and slowly deteriorating. For over a century, citizens and visitors have enjoyed the breathtaking views from the Second Avenue extension into the waters of Tampa Bay. For over four decades, the Inverted Pyramid served as a "modern day lighthouse . . . a beacon for the city," noted William Harvard Jr. of his father's one-of-a-kind structure. As for the future of The Pier and the Sunshine City's next beacon of the bay—only time and tides will tell.

TIMELINE

1854 Lt. C.H Berryman, a US Navy surveyor, constructs a small settlement and short pier near present-day Fifth Avenue North. Although shortly abandoned, William Paul settles the hamlet.

1889 The Railroad Pier is completed by the Orange Belt Railway; a bathing pavilion is added.

1896 The Brantley Pier begins the tradition of piers jutting from Second Avenue Northeast.

1901 Tomlinson's Fountain of Youth Pier opens as the city's first tourist attraction.

1906 The Electric Pier, known for its hundreds of electric lights, extends 3,000 feet into Tampa Bay.

1907 Braaf Pier, a private recreational pier, is built on homestead land that will be the Vinoy Hotel.

1913 The first Municipal Pier is constructed with a $40,000 bond issue approved by voters.

1921 Hurricane damages the Municipal Pier and "cleans" the waterfront of rickety docks and shacks.

1925 Publisher Lew Brown rallies the city with "let's build a Million Dollar Pier" challenge; raises $300,000 in pledges.

1926 The Million Dollar Pier shares a Thanksgiving Day dedication with the Piper-Fuller Airport, the city's first flying field.

1967 The Million Dollar Pier is demolished after four decades of being the city's gathering place.

1969 City council approves a $2 million pier project, to be ready for the 1970–1971 tourist season.

1970 Council earmarks an additional $800,000 to build the Inverted Pyramid. Eventual cost is $4 million.

1973 The Pier opens on January 15, with Marriott Corporation contracted as facility manager.

1977 Marriott does not renew its contract; Hardwicke Companies of Miami gets contract to develop a waterfront theme of restaurants and shops.

1978 The Pier approach deck suffers from saltwater erosion. The repair estimate is $500,000.

1985 A roof leak at The Pier will cost $204,000 to fix.

1986 The Pier closes for $12 million in renovations.

1988 The Pier reopens in August after being closed for 19 months.

1989 Crowds, and problems, return; the operating deficit rises to $1.2 million. Malfunctioning elevators, chronic air conditioning and heating issues, and trolley breakdowns become new issues.

2004 Engineers say the deteriorating approach and base, built in the 1920s, must be replaced within 10 years at a cost of $25 million to $40 million.

2006 City officials announce plans for a $50 million restoration of the 1973 Pier.

2010 City council votes to demolish The Pier.

2011 Council approves three finalists in international design competition, models go on display.

January 2012 Winning design by Michael Maltzan Architecture is called The Lens.

February 2012 Mayor Bill Foster announces The Pier will close on May 31, 2013.

April 2012 Petition to save the 1973 Pier picks up steam. Group offers its own design.

August 2012 City council, ignoring more than 20,000 petition signatures from the group voteonthepier.com, refuses to put the issue on the ballot.

September 2012 A new group, Concerned Citizens of St. Petersburg, emerges to oppose the Lens.

October 2012 A pro-Lens group surfaces, headed by television pitchman Anthony Sullivan.

May 2013 The Pier closes on May 31, 2013. Concerned Citizens turns in a petition to force a referendum halting the Lens.

INDEX

ABOUT THE ORGANIZATION

All images in this book come from the archives of the St. Petersburg Museum of History (SPMoH), located on the approach to the current Municipal Pier. The museum's extensive collection of more than 8,000 photographs is only a small part of the center's repository of artifacts and remnants of our city's past. With an impressive 90-year history of its own, SPMoH is the city's caretaker of historic documentation for future generations. This book on the city's piers was made possible by the enthusiastic support of its executive director Rui Farias, our board members, dedicated supporters like Hazel and William R. Hough, enthusiastic volunteers, and supports like you.

Nevin Sitler, museum director of education and outreach, and a recognized Florida historian, spearheaded the effort of gathering and cataloging these photographs, based on a semipermanent museum exhibit of the city's pier history. As the city council and a local task force of experts, designers, and ordinary citizens determines the fate of a new or rebuilt pier, this history is presented as part of that learning and decision-making process. All author proceeds from the sale of this book go to the museum, to help fund further informational programs and educational efforts.

DISCOVER THOUSANDS OF LOCAL HISTORY BOOKS FEATURING MILLIONS OF VINTAGE IMAGES

Arcadia Publishing, the leading local history publisher in the United States, is committed to making history accessible and meaningful through publishing books that celebrate and preserve the heritage of America's people and places.

Find more books like this at
www.arcadiapublishing.com

Search for your hometown history, your old stomping grounds, and even your favorite sports team.

DISCARD

MADE IN THE USA